FAKE PHOTOS

FAKE PHOTOS

HANY FARID

WITHDRAWN FROM STOCK

The MIT Press | Cambridge, Massachusetts | London, England

This book was set in Chaparral Pro by Toppan Best-set Premedia Limited. Printed and bound in the United States of America.

Library of Congress Cataloging-in-Publication Data

Names: Farid, Hany, author.
Title: Fake photos / Hany Farid.
Description: Cambridge, MA : The MIT Press, [2019] | Series: The MIT Press essential knowledge series | Includes bibliographical references and index.
Identifiers: LCCN 2018058334 | ISBN 9780262537490 (pbk. : alk. paper)
Subjects: LCSH: Image authentication. | Trick photography. | Authentication.
Classification: LCC TA1654 .F37 2019 | DDC 006.4/2--dc23 LC record available at https://lccn.loc.gov/2018058334

10 9 8 7 6 5 4 3 2 1

CONTENTS

SERIES FOREWORD

The MIT Press Essential Knowledge series offers accessible, concise, beautifully produced pocket-size books on topics of current interest. Written by leading thinkers, the books in this series deliver expert overviews of subjects that range from the cultural and the historical to the scientific and the technical.

In today's era of instant information gratification, we have ready access to opinions, rationalizations, and superficial descriptions. Much harder to come by is the foundational knowledge that informs a principled understanding of the world. Essential Knowledge books fill that need. Synthesizing specialized subject matter for nonspecialists and engaging critical topics through fundamentals, each of these compact volumes offers readers a point of access to complex ideas.

Bruce Tidor
Professor of Biological Engineering and Computer Science
Massachusetts Institute of Technology

INTRODUCTION

Stalin, Mao, Hitler, Mussolini, Castro, Brezhnev, and many others had photographs manipulated in an attempt to rewrite history. These men understood the power of photography: if they changed the visual record, they could change history.

Back then, cumbersome and time-consuming darkroom techniques were required to alter the historical record. Today, powerful and low-cost digital technology has made it far easier for nearly anyone to alter digital images. And the resulting fakes are often difficult to detect. This photographic fakery is having a significant impact in many areas of society. Doctored photographs are appearing in tabloids and fashion magazines, government media, mainstream media, fake-news items, social media, on-line auction sites, on-line dating sites, political ad campaigns, and scientific journals. The technologies that can distort and manipulate digital media are developing at break-neck speeds, and it is imperative that the technologies that can detect such alterations develop just as quickly.

Stalin, Mao, Hitler, Mussolini, Castro, Brezhnev, and many others had photographs manipulated in an attempt to rewrite history. These men understood the power of photography: if they changed the visual record, they could change history.

In the Beginning

Nearly two decades ago, I was idly waiting in line at the library when I noticed an enormous book on a cart: *The Federal Rules of Evidence*. As I was thumbing through the book, I came across Rule 1001 of Article X, Contents of Writing, Recordings, and Photographs, which outlined the rules under which photographic evidence can be introduced in a court of law. The rules seemed straightforward, until I read the definition of original:

> An "original" of a writing or recording means the writing or recording itself or any counterpart intended to have the same effect by the person who executed or issued it. For electronically stored information, "original" means any printout—or other output readable by sight—if it accurately reflects the information. An "original" of a photograph includes the negative or a print from it.

I was struck that the definition of "original" included such a vague statement as "or other output readable by sight."

At the time, the internet, digital cameras, and digital editing software were still primitive by today's standards. The trajectory, however, was fairly clear, and it seemed to

me that advances in the power and ubiquity of digital technology would eventually lead to complex issues of how we can trust digital media in a court of law.

This serendipitous event led me on a two-decade quest to develop techniques for authenticating digital content. These authentication techniques work in the absence of any type of digital watermark or signature. Instead, these techniques model the path of light through the entire image-creation process, and quantify physical, geometric, and statistical regularities in images that are disrupted by the creation of a fake.

Initially, the primary application of my digital forensic techniques was to authenticate photographic evidence in criminal and civil proceedings (the term *forensics*, after all, means "pertaining to courts of law"). Occasionally, I was also asked to examine the authenticity of images for law enforcement agencies, news organizations, and private citizens. This balance has shifted in recent years with the increase in the deliberate publication of false information for political or financial gain. Increasingly, I am called upon to examine images and videos that have been disseminated in various media, especially social media. In some of the most alarming cases, the images are fakes created by individuals or state-sponsored entities intent on manipulating elections or inciting civil unrest.

As the uses of fake images have become more insidious, the tools to produce these images have become more sophisticated and widely available. Recent advances in machine learning, for example, have removed many of the time and skill barriers previously required to create high-quality fakes, and the resulting fakes are very convincing. These same automatic tools can also be turned against our forensic techniques through generative adversarial networks (GANs) that modify fake content to bypass forensic detection.

Our ability to authenticate digital information has never been more urgent or more challenging. The goal of this book is to give lay readers an understanding of the underlying principles and primary techniques of image forensics. This knowledge should allow readers to gauge when and to what extent images can be trusted.

This Book

The authentication techniques described in this book all rely on leveraging some aspect of the image recording pipeline: the interaction of light in the physical scene; the refraction of light as it passes through the camera lenses; the transformation of light to electrical signals in the camera sensor; and, finally, the conversion of electrical

signals into a digital image file. At each stage of this image formation process, certain regularities are introduced into the final image. The authentication techniques exploit deviations from these regularities to expose photo manipulation.

Each section of the book describes a different technique for analyzing an image. The sections are intended to stand alone, and techniques that are related by application or process are cross-referenced. The techniques in the first chapter are fairly intuitive; those in the second chapter are a bit more challenging, while the techniques in the third chapter are relatively complex. In each case, I've tried to provide an overview of how the technique works and when it should be applied. The details of the implementation as well as additional techniques are provided in my technical handbook *Photo Forensics* (MIT Press, 2016).

In addition to explaining the idea behind each technique, I have also endeavored to explain how and when the technique should be applied. All of the techniques are based on certain assumptions that limit their applicability, and it is critical for the reader to be cognizant of these limitations. In general, individual techniques can reveal evidence of tampering, but they cannot provide evidence of authenticity. Only in the aggregate can these techniques support (although they can never prove) authenticity.

Although the reader is assumed to have little or no prior knowledge of the topic, it is helpful to have some basic knowledge of how images are recorded, represented, and stored by a camera. If you are unfamiliar with these topics, then I encourage you to start with the Background chapter (chapter 5); otherwise, I welcome you to dive in.

TECHNIQUES REQUIRING MINIMAL TECHNICAL SKILL

This chapter has nine sections, each of which describes an authentication technique that is relatively straightforward to understand and apply.

The first section, Reverse Image Search, describes a simple but potentially definitive way to determine whether an image is being misrepresented. The second technique, Metadata, can uncover basic facts about the photo, such as when and where the photo was taken, and what type of camera was used. The next three, Exposure, Flash, and Eyes and Ears, examine the lighting properties in the photographed scene. These lighting techniques are followed by two more, Photogrammetry101 and Lines, Lines, Lines, that focus on the geometric properties of the scene. The last two techniques, In the Dark and Enhance, can be used to enhance the lighting and geometric properties in a photo.

As is generally the case in photo forensics, each of these techniques is applicable only in certain situations. In addition to describing how each technique works, I have also explained when and how it should be applied as well as when it might give inconclusive or misleading results.

Reverse Image Search

A few years back, I consulted on a case for a federal law enforcement agency. At issue was the authenticity of a couple of photos depicting a gruesome incident. If the photos were real, the law enforcement agents needed to investigate a serious crime, but if they were fake, the agents would need to investigate a cruel prank.

I initially spent some time looking for traces of tampering in the photos, but found no obvious inconsistencies. But like the agents, I was still doubtful that the photos were real because they depicted such improbably gruesome content. A quick internet search with the appropriate key words found one of the two images posted to a chat room, but the source of the image remained unclear. I then performed a reverse image search in which an image is specified (as opposed to keywords), and instances of that image are found (see, for example, www.tineye.com and images.google.com). This reverse image search found more instances, one of which revealed the true nature of

the image content: it was a movie prop. A reverse image search on the other image found that it, too, was a movie prop. What a relief.

In an image-forensic setting it can often be helpful to determine the provenance of an image. Reverse image search is able to find identical versions of an image, as well as variations of that image. These variations may include small additions, deletions, and modifications such as scaling or color/brightness adjustments. In addition, doctored photos might be composed of parts of other images that themselves can be found on-line. As reverse image search technology improves, these tools hold the potential to be highly useful.

Two issues related to using reverse image search for forensic applications should be mentioned. The first is that this technology requires uploading the image to a commercial website, and this may not be possible with sensitive evidence. If the image already exists on the internet, however, it may be possible to first locate it with a keyword search. The second is that these sites cannot exhaustively index the vastly expansive, ever-changing content on the internet. So, even if the image under investigation is on the internet, there is no guarantee that it will have been found and indexed by the site. In this regard, a confirmed match is more informative than the lack of a match.

Metadata

In one of my more unusual digital forensic cases I was asked to examine evidence from a bitter divorce. One spouse had submitted a series of photos as documentation of domestic violence. The other spouse claimed the photos were fake, and I was called in to make an evaluation. My first step in almost every digital forensic case is not to analyze the image itself, but instead to analyze the image *metadata*.

Metadata is data about data. The metadata for a digital image includes the camera make and model, the camera settings (e.g., exposure time and focal length), the date and time of image capture, the GPS location of image capture, and much more. The metadata is stored along with the image data in the image file, and it is readily extracted with various programs, as will be discussed later. Image metadata is stored in a variety of formats, most commonly EXIF, XMP, and IPTC-IIM.[1] I will focus on the EXIF standard because it is used by the majority of commercial digital cameras and mobile devices.

The EXIF standard organizes metadata into five *image file directories* (IFDs): (1) Primary; (2) Exif; (3) Interoperability; (4) Thumbnail; and (5) GPS. The data within each directory is identified with *tags*, as shown in table 1.1. The Primary IFD contains basic information about the image, such as camera make and model and the recording date

Metadata is data about data. The metadata for a digital image includes the camera make and model, the camera settings (e.g., exposure time and focal length), the date and time of image capture, the GPS location of image capture, and much more.

Table 1.1. Image metadata

IFD	Tag	Description
Primary	Make	camera/device manufacturer
Primary	Model	camera/device model
Primary	DateTime	date and time image was last modified
Primary	Software	camera (or photo editing software) name and version
Primary	Copyright	copyright information, if available
Primary	Artist	camera owner, if available
Primary	BatteryLevel	battery level at time of recording
Exif	DateTimeOriginal	date and time image was recorded
Exif	FocalLength	camera focal length
Exif	ExposureTime	exposure time
Exif	FNumber	F-number (F-stop) of lens
Exif	ISOSpeedRatings	light sensitivity of sensor
Exif	SubjectLocation	location in the image of focus point
Exif	SubjectDistance	distance to focus point in scene
Exif	BrightnessValue	brightness of focus point in scene
Exif	Flash	flash fired (1) or not (0)
Interop	RelatedImageFileFormat	file format of image
Interop	InteroperabilityIndex	version number
Interop	InteroperabilityIndex	interoperability rule
Thumbnail	ImageWidth	thumbnail width

Table 1.1. (continued)

IFD	Tag	Description
Thumbnail	ImageHeight	thumbnail height
Thumbnail	Compression	compression method (no compression (1); JPEG compression (6))
Thumbnail	JpegIFOffset	offset to JPEG thumbnail image
Thumbnail	JpegIFByteCount	size of JPEG thumbnail image
GPS	GPSDateStamp	date and time
GPS	GPSAltitude	altitude based on the reference in GPSAltitudeRef
GPS	GPSAltitudeRef	reference altitude (reference is sea level and altitude is above sea level (0); altitude is below sea level (1))
GPS	GPSLongitude	longitude in degrees, minutes, and seconds
GPS	GPSLatitude	latitude in degrees, minutes, and seconds
GPS	GPSLatitudeRef	north (N) or south (S) specification of latitude

and time. The Exif IFD contains information about camera settings, including the shutter speed, aperture size, and focal length. Some device manufacturers also include special device-specific tags, or makernotes, in the Exif IFD. The Interoperability IFD contains information about image format, compression, and cross-device compatibility. The Thumbnail IFD stores the thumbnail image[2] and the GPS IFD stores detailed geo-location information. Camera manufacturers are free to embed any (or no) information into each of these IFDs, and they can create additional IFDs for customized data.

The image metadata provides a great deal of information that can be exploited in a forensic analysis. The importance of the date, time, and location tags is self-evident. Other tags may have a similarly straightforward interpretation: photo-editing software may introduce a tag that identifies the software or it may introduce additional date/time tags that are inconsistent with the existing date/time tags. Other tags identify the camera make and model, which are needed in many forensic techniques.

A comparison of an image's metadata and its content may reveal more clues: several tags provide information about camera settings that should be reflected in the observable properties of the image. A gross inconsistency between the image properties implied by these settings and the actual properties of the image provides evidence

that the image has been manipulated. For example, the exposure time and aperture size tags provide a qualitative measure of the light levels in the photographed scene. A short exposure time and small aperture suggest a scene with high light levels, while a long exposure time and large aperture suggest a scene with low light levels. In addition, images taken with a short exposure time should have minimal motion blur, and images taken with a large aperture should have a narrow depth of field (only objects at the point of focus will be sharp, while the remaining parts of the image will be blurry). See Exposure for more details on these properties. Images taken with auto-focus may include a subject distance tag. The distance associated with this tag is only a rough estimate, but it may still provide useful information for a photogrammetric analysis (see Measuring Distance). The use of the camera flash is recorded in the flash fired tag. The presence or absence of the camera flash can be compared against the lighting in the scene (see Flash).

Metadata can also be used to match an image with a particular type of device. As noted above, each manufacturer chooses which tags to include in each IFD and they may add their own IFDs with customized tags. When an image is edited and resaved, the image metadata may be modified, augmented, or stripped by the photo-editing software, mobile app, or on-line service. If the image's metadata format is not the same as that of the original

device, this would strongly suggest that the image has been modified after its initial recording.

Many commercial and open-source programs are available for extracting image metadata, including software packages such as Adobe Photoshop and GIMP. Many of these programs provide an interpretation or summary of the metadata rather than the raw data itself, so care should be taken in making any inferences about the lack of certain metadata tags.

While an inconsistency in the metadata is informative, the absence of an inconsistency may not be. Metadata can be modified to conceal evidence of manipulation. In addition, because many software and on-line services strip out much of an image's metadata, the majority of images found on-line will not have metadata. As a result, the absence of metadata is not uncommon and the ease with which metadata can be modified should be considered even when the metadata appears to be intact.

In the case of the bitter divorce, I found that the image metadata was perfectly intact; the date, time, and GPS location were each consistent with other aspects of the report of domestic violence. This, of course, did not prove that the image was authentic, but it was a good first step to a more detailed analysis that further upheld the conclusion that the images were real.

Exposure

Of all the analysis requests I receive, those involving images of UFOs interest me the least and I usually decline. A few years back, however, I was presented with a particularly convincing image of a UFO. It was not the usual blurry, dark, noisy, low-resolution image of a speck in the sky. Instead, this photo was of high quality and resolution and clearly showed a large alien-like object. After verifying that the metadata was intact, I dug a bit deeper into the relationship between the metadata and the image content.

Because metadata typically describes the camera settings at the time a photo was taken, it makes certain predictions about the image content. To understand these predictions, it is necessary to know a bit about the many automatic adjustments cameras make to ensure images are focused and properly exposed. These adjustments alter the location of the lenses, the size of the aperture, the speed of the shutter, and the sensitivity of the electronic sensor. Once the adjustments have been made, the camera aperture opens to the specified size for the specified duration, and the incoming light is focused by the lenses and recorded by the sensor with the appropriate gain (sensitivity). All of this happens in a fraction of a second. Before we return to the UFO case, let's look at the effects of each of these adjustments on an image of an ordinary scene—a

A few years back, I was presented with a particularly convincing image of a UFO. It was not the usual blurry, dark, noisy, low-resolution image of a speck in the sky. Instead, this photo was of high quality and resolution and clearly showed a large alien-like object.

girl at the playground, as seen in figure 1.1. To make comparisons easy, in this and the other figures in this section, I am simulating the effects of the camera settings on a single scene.

The size of the aperture controls how much light enters the camera: the larger the aperture, the more the light that enters. The three images in the first column of figure 1.1 show from top to bottom the effects of reducing the aperture size. A large aperture (top) allows in too

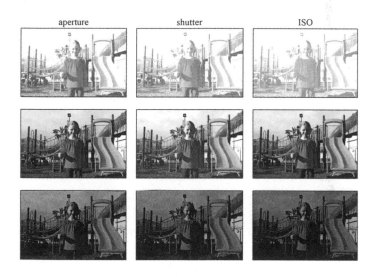

Figure 1.1 The images in the top row are taken with a large aperture (left), slow shutter (middle), and high ISO (right). From top to bottom are the results of reducing the aperture, increasing the shutter speed, and reducing the ISO. (Source: CameraSim.com)

much light, overexposing the image. A small aperture (bottom) allows in too little light, underexposing the image. An intermediate aperture (middle) produces properly exposed images in which the pixel values span the full range of black to white and no pixel values are saturated at pure black or white.

The shutter speed—how long the aperture remains open—also controls how much light enters the camera: the slower the speed the more light that enters. The three images in the middle column of figure 1.1 show from top to bottom the effects of an increasingly faster shutter speed. A slow shutter speed (top) allows in too much light, overexposing the image, while a fast shutter speed (bottom) allows in too little light, underexposing the image.

We have seen that the aperture size and shutter speed control how much light enters the camera. How much light is needed is determined by the sensitivity of the camera sensor, which is measured in ISO (the acronym for International Standards Organization). The smaller the ISO, the lower the gain of the sensor and the more light needed to properly expose the image. On a bright, sunny day an ISO of 100 or 200 is adequate to produce a well-exposed image. To achieve the same exposure in a dimly lit room, the sensitivity of the sensor must be increased, and an ISO of 1600 or 3200 may be needed. In general, when the incoming light is halved, the ISO must be doubled to

maintain the same level of exposure. The three images in the third column of figure 1.1 show from top to bottom the effects of reducing the ISO on the image. A large ISO (top) increases the sensitivity of the sensor, overexposing the image. A small ISO decreases the sensitivity of the sensor, underexposing the image.

Although the aperture size, the shutter speed, and the ISO can each be used to regulate image exposure, they are not interchangeable. As we will see, each of these settings has a distinctive effect on other qualities of the image. The image in the top panel of figure 1.2 simulates a photograph with a large aperture and fast shutter speed; the image in the bottom panel simulates a photograph with a small aperture and slow shutter speed. Although the same amount of light entered the camera in both cases, the images appear different. One difference is the range of distances that are in focus, or the *depth of field*. In the top image the foreground is focused but the background is not, while in the bottom image both the foreground and background are in focus. The difference in depth of field is due to the difference in aperture size: the smaller the aperture, the greater the range of distances that are in focus (this is why squinting can help you see more clearly). A second difference between the images is the blurriness of moving objects. In the top image the pinwheel arms appear crisp; in the bottom image the arms are blurred. This difference in *motion blur* is due to the difference in shutter

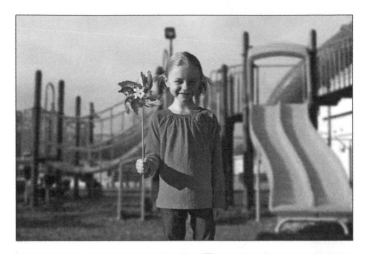

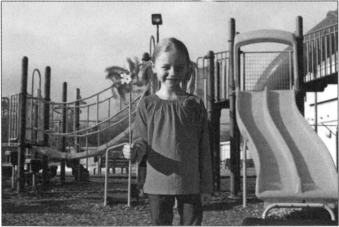

Figure 1.2 Similarly exposed images but with different camera settings: the upper image has a large aperture and fast shutter speed leading to a small depth of field and relatively little motion blur, and the lower image has a small aperture and slow shutter speed leading to a large depth of field and a motion blurred pinwheel. (Source: CameraSim.com)

speed: a fast shutter captures the image before the object has moved an appreciable distance.

The ISO setting also has a predictable effect on image quality. The images in figure 1.3 are similar in being well exposed even though they correspond to very different light conditions. The ample illumination condition (left) has an ISO of 100, while the low illumination condition has an ISO of 6400 (the aperture size and shutter speed were the same). The effect of ISO on image quality is easiest to see when the image is enlarged. The enlarged view of the girl's left eye reveals random speckles or noise in the image with the large ISO. Increasing the ISO compensates for low light levels by increasing the gain (the sensitivity) of the sensor, but this also increases the gain on the random electrical fluctuations within the camera, resulting in a noisy image (see Sensor Noise).

As we have seen, the settings for aperture size, shutter speed, and ISO are related to the light level in the scene. If an image of a dark indoor scene is well exposed, we can assume that it was taken with a large aperture, a slow shutter speed, or a high ISO. To infer the specific settings that were used, we can examine other qualities of the image. If the depth of field is shallow, the aperture was probably large. If there is noticeable motion blur, the shutter speed was probably slow. If there is noise in the image, the ISO was probably high. We can then compare the settings we infer with the settings reported in the image metadata

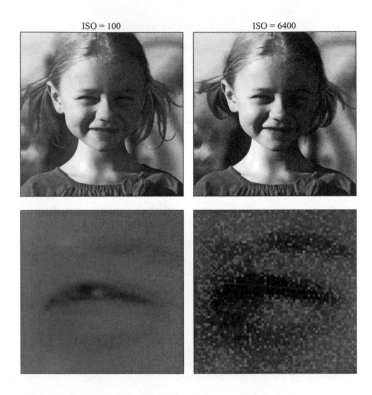

Figure 1.3 These simulated images are of a well-lit scene photographed with an ISO of 100 (left) and a low-light scene photographed with an ISO of 6400 (right). Shown below each image is a magnified portion of the eye revealing significant differences in the image quality. (Source: CameraSim.com)

(see Metadata). If the inferred setting and the metadata settings do not match, the image should be examined further for evidence of tampering.

With this descriptive overview in mind, let's now look at the quantitative relationship between the camera settings and three properties of the image: exposure, depth of field, and motion blur. We will then return to the UFO image to check whether the camera settings match the image content.

Light

Aperture size is specified relative to the camera's focal length f. The ratio N of the focal length f to the aperture diameter D is the f-number or f-stop. Because the f-number is inversely proportional to the aperture diameter D, a small f-number corresponds to a large aperture. F-numbers, denoted as f/N, typically range from $f/1.4$ (large aperture) to $f/32$ (small aperture). The shutter speed T is specified in seconds, and it typically ranges from 1/1000 of a second to 1/2 a second or longer. Typical ISO values S range from 50 to 3200 but can be smaller or larger depending on the camera.

Whether an image is properly exposed depends on the relationship between the camera settings and the amount of light in the scene, or brightness. For well-exposed photos, the relationship between brightness, B, and the

camera settings (f-number N, shutter speed T, and ISO S) is embodied by the exposure equation:

$$T = \frac{N^2}{SB}$$

The exposure equation can be rewritten in a different form that more clearly shows the trade-off between the camera settings. This form, the APEX (Additive Photographic Exposure System) is given by:

$$A_v + T_v = S_v + B_v,$$

where the aperture value A_v, time value T_v, sensitivity value S_v, and brightness value B_v are defined as:

$$A_v = 6.64 \log(N)$$

$$T_v = -3.32 \log(T)$$

$$S_v = 3.32 \log(S) - 1.66$$

$$B_v = 3.32 \log(B) + 1.66.$$

Table 1.2 provides a range of camera settings expressed in traditional and APEX units. The APEX exposure equation tells us that if, for example, the sensitivity value is $S_v = 5$ and the brightness value is $B_v = 6$, then the sum

Table 1.2. Conversion between traditional (N, T, S, B) and APEX values (A_v, T_v, S_v, B_v). For a well-exposed photo, the APEX values satisfy the exposure equation $A_v + T_v = S_v + B_v$.

aperture		shutter		sensitivity (ISO)		scene brightness	
N	A_v	T	T_v	S	S_v	B	B_v
1.0	0	1	0	3.1	0	0.3	0
1.4	1	1/2	1	6.2	1	0.6	1
2.0	2	1/4	2	12.5	2	1.3	2
2.8	3	1/8	3	25	3	2.5	3
4.0	4	1/15	4	50	4	5.1	4
5.6	5	1/30	5	100	5	10.2	5
8.0	6	1/60	6	200	6	20.4	6
11.3	7	1/125	7	400	7	40.7	7
16.0	8	1/250	8	800	8	81.5	8
22.6	9	1/500	9	1600	9	163.0	9
32.0	10	1/1000	10	3200	10	326.0	10
48.0	11	1/200	11	6400	11	652.0	11

of the aperture and shutter values must be 11. This can be achieved with an aperture value of $A_v = 1$ (*f/1.4*) and a shutter value of $T_v = 10$ (*T* = 1/1000 sec), or, at the other extreme, an aperture value of $A_v = 10$ (*f/32.0*) and a shutter value of $T_v = 1$ (*T* = 1/2 sec).

The camera settings *N, T, S* involved in the exposure equation can be extracted from the image metadata (see Metadata). In some cases, these settings will also be available in APEX units (typically with tag names like `ApertureValue`, `ShutterSpeedValue`, and `BrightnessValue`). The brightness value B_v may also be recorded in the metadata, but often it is not. When the brightness value is unavailable, it can be inferred from the scene content. Table 1.3 provides a range of

Table 1.3. Typical range of brightness values B_v for familiar outdoor and indoor illuminations

illumination	B_v (range)
outdoors in full moonlight	−8 – −6
outdoors at dusk	−5 – −3
dark room	−2 – 0
dimly lit room	1 – 3
well-lit room	4 – 6
outdoor cloudy or hazy day	7 – 9
outdoor sunny day	10 – 12

typical brightness values for familiar outdoor and indoor illuminations.

The relationship between the scene illumination and the camera settings that control exposure can be used to qualitatively verify that the camera settings match the apparent illumination and brightness in an image.

Depth of field

When a camera is perfectly focused at a distance d, a point at that distance will appear as a point in the image. A point that is nearer or farther than d will appear as a disc in the image. This disc is referred to as the *circle of confusion*. If the distance of the point differs only slightly from d, then the circle of confusion will be minuscule, and the point will still appear focused. The range of distances around d that appear focused is the *depth of field*. Another way to describe the depth of field is that it is the range of distances that produce a circle of confusion that is less than some threshold. A natural threshold for a digital image is the size of a pixel.

As noted earlier, the depth of field depends on the camera's aperture size. It also depends on d, the distance at which the camera is focused. When the camera is focused at a distance d, the depth of field is characterized by a near distance d_n and a far distance d_f, which are defined relative to the *hyperfocal distance*:

$$d_n = \frac{d \times d_h}{d_h + d} \quad \text{and} \quad d_f = \frac{d \times d_h}{d_h - d}$$

where d_h is the hyperfocal distance defined as $d_h = f^2/(Nc)$, f is the focal length, N is the f-number, and c is the diameter of the circle of confusion. If the camera is focused at a distance $d = d_h$, then the depth of field ranges from a near distance of $d/2$ to a far distance of infinity. That is, in the above equation if $d = d_h$, then $d_n = d^2/(2d) = d/2$, and $d_f = d^2/(d - d) = $ infinity. If the far distance d_f evaluates to a value less than zero, then $d_f = $ infinity.

Table 1.4 shows how the depth of field varies with f-numbers ranging from $f/1.4$ to $f/32$ and focus distances of 1, 5, 10, and 20 meters. This table assumes a 50 mm focal length and a circle of confusion threshold of $c = 0.035$ mm, which is reasonable for a 35 mm camera (this circle of confusion corresponds to one pixel in a camera with a sensor width of 35 mm and 1,000 pixels). Notice that as the aperture gets smaller (i.e., the f-number gets larger), the depth of field increases, and as the focus distance d increases, the depth of field also increases.

The depth of field can be calculated directly using the above equations or it can be obtained from a variety of on-line calculators or tables. This calculated depth of field can be compared with the apparent depth of field in an image.

Table 1.4. The depth of field defined by a near distance d_n and far distance d_f for a camera with focal length $f = 50$ mm, a circle of confusion with diameter $c = 0.035$ mm, and a range of aperture sizes f/X and viewing distances d

	d = 1		d = 5		d = 10		d = 20	
f-number	d_n	d_f	d_n	d_f	d_n	d_f	d_n	d_f
f/1.4	0.98	1.02	4.55	5.54	8.35	12.5	14.3	33.1
f/2	0.97	1.03	4.39	5.80	7.82	13.9	12.8	45.3
f/2.8	0.96	1.04	4.18	6.22	7.17	16.5	11.2	95.0
f/4	0.95	1.06	3.91	6.92	6.42	22.6	9.45	∞
f/5.6	0.93	1.08	3.59	8.22	5.59	47.2	7.75	∞
f/8	0.90	1.12	3.22	11.2	4.73	∞	6.18	∞
f/11	0.87	1.18	2.80	23.2	3.88	∞	4.81	∞
f/16	0.82	1.27	2.37	∞	3.10	∞	3.66	∞
f/22	0.77	1.43	1.95	∞	2.41	∞	2.73	∞
f/32	0.70	1.74	1.55	∞	1.83	∞	2.01	∞

Motion blur

Objects may appear out of focus because they lie outside of the depth of field or because they are moving relative to the camera. If the camera is moving while the shutter is open, then the entire image will be blurred. If an object in the scene is moving relative to a stationary camera, then only the object will be blurred. Figure 1.4 shows two simulated

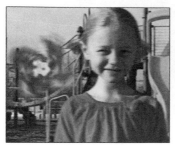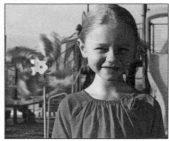

Figure 1.4 Motion blur with a shutter speed of 1/25 sec (left) and 1/60 sec (right). (Source: CameraSim.com)

images of the girl with a pinwheel photographed with two shutter speeds: 1/25 sec on the left and 1/60 sec on the right. In both cases, the fast spinning pinwheel is blurry. The girl is also blurry in the left image because both she and the camera moved appreciably in the 1/25 sec that the shutter was open.

We can predict the amount of motion blur in an image if we know the camera focal length f mm, the shutter speed T seconds, and the size of the sensor in mm s and pixels p. We assume that the camera is perfectly still, and the object is moving at a speed of m degrees/second (by way of intuition, your thumb held at arm's length is approximately 1 degree of visual angle, and your fist is approximately 5 degrees of visual angle). As shown in figure 1.5 the field of view of the camera, in degrees, is $v = 2\tan^{-1}(s/2f)$. An object

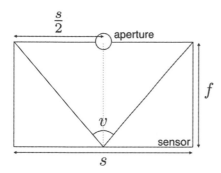

Figure 1.5 A camera's field of view is $v = 2\tan^{-1}(s/2f)$.

moving m degrees/second for T seconds will therefore be blurred over a region of size:

$$(m \text{ deg/sec}) \times (T \text{ sec}) \times \frac{p \text{ pixels}}{v \text{ deg}}$$

where the last term converts from degrees to pixels. Consider, for example, a camera with a focal length $f = 50$ mm, a shutter speed of $T = 1/60$ sec, and a sensor with a width of 35 mm and 3,000 pixels. This camera's field of view is $v = 2\tan^{-1}(35 / (2 \times 50)) = 38.58$ degrees. An object moving 5 degrees per second will then be blurred over a region of size $(5) \times (1/60) \times (3000/38.58) = 6.48$ pixels.

As we've seen, the amount of motion blur caused by a moving object can be calculated from an estimate of the object's speed and knowledge of the sensor size and focal

length. Motion caused by camera shake is more difficult to quantify. A good rule of thumb for a handheld camera of focal length f is that there will be minimal motion blur resulting from camera shake when the shutter speed is faster than $1/f$ seconds.

Unidentified Flying Objects

Let's now return to the UFO image that clearly showed a large alien-like object in the sky. I started by analyzing the image metadata, which was intact. From the image metadata, I extracted the values for the f-number N, shutter speed T, and ISO S and converted them to APEX units to yield values for A_v, T_v, and S_v. The sum of A_v and T_v was 8 and S_v was 5, meaning that the scene brightness B_v was 3 corresponding to a dimly lit room. This didn't make sense, since the well-exposed photo was clearly taken outdoors on a bright sunny day. Something was clearly wrong. After a little more digging I discovered that the photo was a composite. To make the final JPEG image and metadata consistent with an original image taken with a digital camera, the forger had cleverly rephotographed the fake being displayed on a high-quality monitor; the exposure settings were inconsistent with what the scene depicted.

Flash

A recent heartbreaking case of wrongful death depended on the need to distinguish photographs taken with a flash from those that were not. This related to how the light from a camera flash reflects off the human eye (e.g., red-eye) and involved the question of whether the photos showed an unusual reflection that was the result of a diseased eye.

You may recall that camera flash activity is often specified in the image metadata (see Metadata) But I needed additional evidence, because some devices do not accurately populate this metadata field. Camera flash can leave telltale signs in the image, signs that are revealed in the pattern of scene illumination.

Lighting

The two computer-generated scenes in figure 1.6 are identical except one is rendered with a simulated camera flash and one is rendered with a distant light source like the sun. (Computer-generated [CG] scenes are accurate models of a real-world scenes. I use CG-content for illustrative purposes because it allows me to strip out extraneous images features and focus solely on the effect of interest.)

You should notice that the pattern of shading on the walls and ground in figure 1.6 are quite different in the two scenes. In the scene illuminated by the flash, the sidewalls

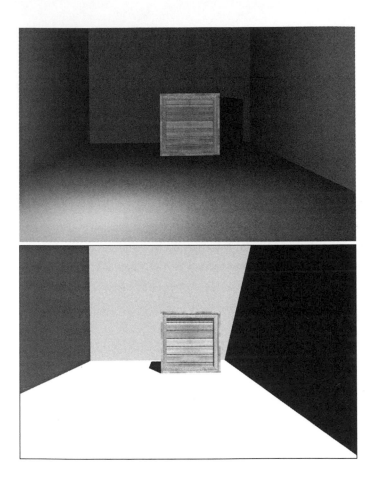

Figure 1.6 The upper scene is illuminated by a nearby light source (camera flash) while the lower scene is illuminated by a distant light source (sun) resulting in differences in the pattern of lighting and shadows.

and ground grow darker as they recede from the camera. In addition, the back wall is more uniformly lit compared to the sidewalls. In the scene illuminated by sunlight, each surface is uniformly lit, and the ground is brighter than the back wall, which is brighter than the sidewall (the wall on the right is in shadow because the sun is positioned above and to the right).

The differences reflect the geometry of the scene relative to the location of the light source. The amount of light that strikes a surface decreases as the angle between the surface and light increases. (More precisely, the amount of light that strikes a surface is proportional to the cosine of the angle between the surface and the light, and the cosine decreases as the angle increases.) Figure 1.7 illustrates this effect: the vertical surface on the left is illuminated by a nearby light source (white circle). As the surfaces recedes from the light source, the angle of the light rays reaching the surface increases and the illumination on the surface decreases accordingly. In contrast, the surface on the right is illuminated by the sun, a distant light source. As a result, the angle of the light rays reaching the surface does not vary, and the surface is equally illuminated.

There is a secondary effect at play here as well. The amount of light that reaches a surface decreases with distance. For a nearby light, such as a flash, this effect is significant because distance may change considerably across the surface. For a distant light such as the sun, this effect

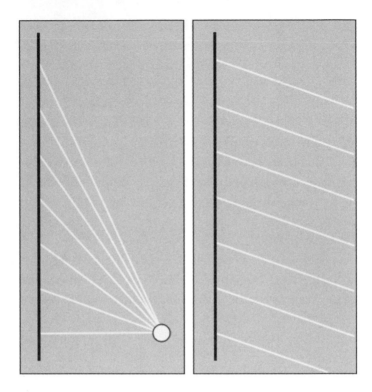

Figure 1.7 A surface (black line) is illuminated by a nearby light (left) and distant light (right). The angle at which a nearby light strikes the surface increases as the surface recedes in distance. The angle at which a distant light strikes the surface remains constant across the surface.

is minuscule. Combined, the effects of angle and distance produce illumination gradients that are a telltale sign of a nearby light source, like a flash. These typically large effects of lighting are an effective means to distinguish between a scene photographed with and without a camera flash.

Shadow
You should also notice the distinctive difference between the cast shadows in the two panels of figure 1.7. The camera flash results in a cast shadow on the surface directly behind the box, whereas the sun results in a cast shadow on the ground. Like the overall pattern of lighting, another telltale sign of a camera flash is the presence of cast shadows directly behind the subject of the photograph.

Reflection
A third telltale sign of a camera flash is the presence of the flash's reflection in eyes (see Eyes and Ears). Because eyes have a glossy surface, they mirror what they see. When a person looks toward a camera with a flash, a small white reflection will often be visible in their eyes. Because the visibility of this reflection depends on the relative position and orientation of the camera and the eyes, the absence of a reflection does not necessarily mean that the camera flash did not fire. In this regard, the presence of the reflection is more informative than its absence.

Understanding the nature of the differences in lighting, shadows, and reflections that result from different types of light sources is a valuable first tool in understanding the properties of the photographed scene. This knowledge can be used to evaluate consistency within an image and across the image and the image metadata (see Metadata and Exposure).

Eyes and Ears

Over the years, my colleagues and I have developed a variety of forensic tools by reasoning about the processes involved in forming and manipulating digital images. I have then applied these tools when consulting on forensic cases. Every once in a while, this process works in the opposite direction, and a case comes to me that inspires a new forensic technique. I will tell the story behind two such cases.

Eyes
An editor for a large media outlet was offered a photo from a smaller outlet. The photo depicted the cast of a popular television show. Something about the lighting and composition seemed wrong to the editor and so he sent the photo to me for analysis.

My first impression was that the lighting on the cast members seemed inconsistent. Staged lighting can be highly complex, however, and I thought it possible that these seeming inconsistencies were just a matter of an unusual placement of lights. As I started to explore the photo in more detail, however, I noticed something peculiar about the eyes of the actors.

Because the surface of the eye is glossy, it reflects back to the camera what it sees. The most visible reflection in the eye is the light sources in the scene, figure 1.8. In the photo, one cast member's eyes reflected a single small spot, suggesting that the illumination was a camera flash (see Flash). The reflection in another cast member's eyes was a single larger reflection, suggesting a more diffuse light

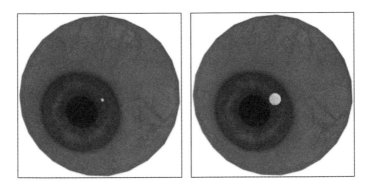

Figure 1.8 The size of the bright reflection in the eye corresponds to the size of the light source.

source. The reflection in the remaining two cast members' eyes was a pair of two diffuse lights.

These reflections' patterns were so different from one another that it seemed unlikely that all four of the cast members were photographed together. After a series of phone calls to the contributing news outlet, it was revealed that the photo was in fact a composite of three separate photos. Apparently, the cast members were not getting along and didn't want to sit for a single photo.

For months after analyzing this photo I was obsessed with the reflection of lights in people's eyes. This obsession eventually led to a new forensic technique. (Because the technique involves a fair amount of mathematics, I am not describing it here.) In lieu of a geometric analysis of the light reflections in a person's eyes, you can use the presence and size of the reflection to reason about the surrounding light sources in the scene. Large inconsistencies in the light sources may be an indication of photo tampering.

Ears

Back in 2016, *Time* magazine published an article entitled "Barack Obama and Joe Biden's Great American Bromance" with a beautiful collection of photos of President Obama and Vice President Biden. One of these photos shows the duo playing golf on what appears to be a putting green

at the White House. A skeptical news editor asked me to verify the integrity of this photo. I subjected it to a series of forensic analyses, including a lighting and shadow analysis, each of which failed to uncover any evidence of manipulation. Shortly after discussing these results with the skeptical news editor, I mentioned this case to a friend and colleague, Michael Black. He made the clever observation that the president's left ear provided further information about the lighting in the scene.

Because the ear is translucent, some light is reflected, and some is transmitted through the ear. The transmitted light, passing through the skin, appears very different than the reflected light. You can try this for yourself, as I did. Standing in front of a mirror, place a flashlight behind your ear, and you will see that your ear appears translucent and red in color. Place the light in front and you will see that your ear appears similar in color to the rest of your face.

Admittedly, knowing that the light was behind the president did not provide a tremendous amount of information, but it was consistent with the other lighting and shadow analyses that placed the light behind the president. Although this observation provides a relatively small bit of information, it is reliable and so has a place in our forensic toolbox.

Photogrammetry 101

Incredible images are often just that—not credible. But occasionally unbelievable images are actually real, so an analyst must be wary of jumping too quickly to conclusions based solely on suspicious content.

Based on its content, the image in figure 1.9 appears to be an obvious fake: the woman seems impossibly small compared to the man. But this is actually a classic perspective illusion that is possible because of the fundamental loss of information that occurs when objects in the three-dimensional scene are projected onto a two-dimensional camera sensor. In the absence of other cues, there is no way of determining whether an object in an image is small and nearby or large and distant. This size-distance ambiguity is inherent in all images. The illusion works because we assume that the chair is a unitary object, but it is actually multiple objects: there is an oversized seat located in the back of the room and four cut-off legs located in the front of the room. The image was taken from a vantage point that perfectly aligns the two halves of the chair. When we view the image, we resolve the size-distance ambiguity using a cue that seems highly trustworthy: we assume that what looks like a chair is actually a chair. So, instead of perceiving the man and woman to be of similar size and at different distances, we erroneously perceive them to be at the same distance and very different in size (although

Figure 1.9 A classic perspective illusion.

the shadows being cast onto the side and back walls hint toward the reality of the scene).

This size-distance ambiguity is inherent in all images, and it gives forgers an extra degree of freedom: they can make something look near or far simply by changing its size. As we've just seen, images do not contain sufficient information to disambiguate size and distance. Fortunately, the image metadata may provide clues (see Metadata). To understand the clue provided by the metadata, we must return to the perspective projection model for the camera obscura (see chapter 5, Background).

Because the geometry is easier to visualize, I'll first consider a one-dimensional (1-D) sensor and then extend it to a two-dimensional (2-D) sensor.

1-D sensor

In a pinhole camera, light emanating from a point in the scene (X, Z) enters the camera pinhole $(0,0)$ and strikes the sensor at location x at a distance f (the focal length) from the camera pinhole (see Background). Consider the pair of shaded triangles in figure 1.10. The smaller triangle is defined by the points $(0, 0)$, $(0, f)$, and (x, f). The larger triangle is defined by the points $(0, 0)$, $(0, Z)$, and (X, Z), where Z is the distance to the point in the scene. Because these triangles are similar, their sides are proportional yielding the perspective projection equation:

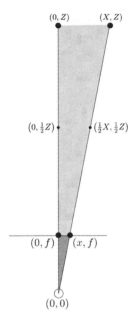

Figure 1.10 Deriving the perspective projection equation.

$$\frac{X}{x} = \frac{Z}{f}$$

Cross-multiplying yields the following relationship between the image coordinate (x) and the scene coordinates (X and Z) and focal length (f):

$$x = \frac{fX}{Z}$$

Consider the line segment in the scene between points *(0, Z)* and *(X, Z)*. The length of this segment is X and it projects to the length x in the image sensor. If we shift this line segment to the left or right, its length on the sensor will not change.[3]

The above perspective projection equation defines the relationship between size in the scene X, size on the sensor x, distance from the camera Z, and camera focal length f. This equation also reveals the size and distance ambiguity inherent in perspective projection. If we double the size of X and at the same time double its distance, the image will not change:

$$x = \frac{2fX}{2Z} = \frac{fX}{Z}$$

Conversely, we can change the size of an object's image by either changing its actual size or by doubling its distance. The perspective illusion described above demonstrates the size-distance ambiguity, but it also suggests a way to overcome it.

We recognize that our perception of the above image is illusory because we know the woman cannot be as small as she appears. People come in a finite range of sizes, and some objects, especially standardized manufactured objects, have a precise size. We should be able to combine information about the object's known size and its size in the image to begin to recover depth.

If the quantities (f and X) on the right-hand side of the perspective projection equation are known, then it is straightforward to compute the distance Z by cross-multiplying and solving for Z:

$$Z = \frac{fX}{x}$$

There is, however, a small complication that arises in practice. On the right-hand side of the above equation, the focal length f and size X are specified in real-world units (say centimeters). The size x measured in the image, however, will be specified in pixels, not centimeters. We must, therefore, convert x from pixels to centimeters. This conversion requires knowing the physical size w_c (in centimeters) of the image sensor and the number of pixels w_p in the sensor. The ratio $w = w_c/w_p$ converts from pixels to centimeters to yield a measure of distance in centimeters:

$$Z = \frac{fX}{wx}$$

Alternatively, the size of an object X in the scene can be estimated from knowledge of its distance Z:

$$X = \frac{wxZ}{f}$$

2-D sensor

Extending this analysis from a 1-D sensor to a 2-D sensor is straightforward. A 3-D point in the scene (X, Y, Z) is projected to a 2-D sensor with image coordinates (x, y):

$$x = \frac{fX}{Z} \quad \text{and} \quad y = \frac{fY}{Z}$$

We seek a relationship between the length of a line segment in the scene L and its length in the image sensor l. As in the 1-D case, we assume that the ends of the line segment are at the same distance Z from the camera. Although it is not particularly difficult, I will forgo the algebraic derivation of this relationship because the result is straightforward and intuitive:

$$Z = \frac{fL}{l}$$

This relationship is the same as in the 1-D case because we have limited ourselves to measuring a 1-D line segment in the scene at a fixed distance from the camera.

As in the 1-D case, the length l in the image sensor needs to be converted from pixels to real-world units:

$$Z = \frac{fL}{wl}$$

where the focal length f can be determined directly from the image metadata (see Metadata).[4] The camera make and model can also be determined from the image metadata. An on-line search for the camera specifications will produce the sensor width (or height) in centimeters and pixels w_c and w_p, from which the conversion factor $w = w_c/w_p$ can be determined.

Let's see now how to apply this geometric analysis. According to the equation $Z = fL/wl$, we can determine how far an object is from the camera (Z) if we can measure its width or height in the image (l), if we know its actual size (L), and if we have some information about the camera (f, w).

Perhaps the trickiest part of this analysis is specifying an actual size (L). One of my favorite solutions for images of people is to leverage the observation that the interpupillary distance (IPD)—the distance between the two eyes as measured between the center of the pupils—is fairly constant among people. The average IPD for adult men is 6.5 cm and the average IPD for adult women is 6.2 cm.

This technique was particularly helpful in the analysis of a gruesome photo that showed a beheading (one person holding the head of another). Using the assumed IPD of 6.5 cm for adult males, I was able to determine that the geometry of the scene was not plausible, but rather a grotesque prank photo.

Lines, Lines, Lines

While many motion picture directors are known for their dramatic flair, J. J. Abrams is unique in being known for his lens flare. When viewed directly, a bright light may appear to emanate streaks. The streaks are an optical aberration that arises when light is scattered within an imaging system, such as an eye or a camera. Streaks and the related optical effects that produce elliptical shapes or *starbursts* are referred to as lens flare. In his movies *Star Trek* and *Star Wars: The Force Awakens*, Abrams used the optical effect of lens flare to create a futuristic touch. Ironically, the process of creating lens flare is decidedly low tech, and the technique for analyzing lens flare is similarly straightforward.

Lens flare and several other image phenomena can be analyzed simply by tracing lines in the image. As we'll see below, an analyst can use the vanishing points of these lines to test for geometric consistency. If the tests reveal an inconsistency in the image, the authenticity of the image should be questioned. Although these line analyses do not require sophisticated computations, they do require judicious application. At the end of this section, I'll discuss several caveats that should be kept in mind when performing the line analyses. Let's begin by considering the geometry of vanishing lines.

Vanishing Lines

If you imagine railroad tracks receding into the distance, you will likely visualize them converging to a *vanishing point* on the horizon. Although the vanishing point is a familiar concept to us now, it wasn't well understood until the fifteenth century. Before this time, artists appear to have been unable to accurately depict three-dimensional space on a two-dimensional canvas. The fact that vanishing points had to be discovered suggests that violations in perspective geometry may be unnoticeable to most observers. Nonetheless, a trained analyst can use the following geometric constraints to look for evidence of photo tampering:

Parallel receding lines converge at a vanishing point

The lines between the tiles in figure 1.11 [plate 1] (left) are parallel in the scene. When imaged, these lines all converge at a vanishing point. If parallel lines in the scene recede in depth from the camera, then a vanishing point will exist, although it may fall outside the image. If parallel lines in the scene do not recede in depth—that is, if they are exactly parallel to the camera sensor (at any distance)—then the parallel lines are imaged as parallel lines, and for practical purposes we can consider the vanishing point to be at infinity.

This geometry emerges from the basics of perspective projection. Recall that under perspective

projection a point (X, Y, Z) in the scene is imaged to a point $(fX/Z, fY/Z)$ where f is the camera focal length. Because the location of the point in the image is *inversely* proportional to the distance Z, the projected points compress as a function of distance, leading to converging lines in an image.

Parallel lines on parallel planes converge to the same vanishing point The far box in figure 1.11 [plate 1] (right) is aligned with the tiles on the floor such that the edges of the box are parallel to the lines between the tiles. Because parallel lines on parallel planes share a vanishing point, the vanishing point for the sides of the box and the tile floor are the same.

Figure 1.11 [Plate 1] Parallel lines on the same plane share a vanishing point (left); and parallel lines on parallel planes share a vanishing point (right).

The vanishing points for all lines on a plane lie on a vanishing line An image may contain many sets of parallel lines, each converging to a different vanishing point, as shown in figure 1.12 [plate 2] (top). If the sets of parallel lines span the same plane in the scene, their vanishing points will lie on a *vanishing line*. The orientation of the vanishing line is determined by the rotation of the camera relative to the plane spanned by the parallel lines. In figure 1.12 [plate 2] (top) the vanishing line is perfectly horizontal because the camera is not rotated relative to the tiled floor.

The vanishing points for all lines on parallel planes lie on a vanishing line The vanishing point for sets of parallel lines on parallel planes will lie on the same vanishing line. Because the tops of the boxes are parallel to the tiled floor, the vanishing points for each of the boxes in figure 1.12 [plate 2] (middle) lie on the vanishing line defined by the vanishing points of the tiled floor.

Three mutually perpendicular sets of parallel lines specify the image's principal point The *principal point* of an image corresponds to the intersection of the camera's optical axis and sensor. Because an image has only one principal point, an analyst can use multiple sets of lines to calculate this point and look for inconsistencies.

Figure 1.12 [Plate 2] Vanishing points and line: (top) two vanishing points (blue) define a vanishing line (red); (middle) vanishing points converge to the vanishing line; and (bottom) three mutually perpendicular vanishing points (blue) define the principal point (red).

To explain the calculation of the principal point, it is necessary to first define two terms that describe a triangle. For each side of the three sides of a triangle, there is one line, the *altitude*, that extends perpendicularly from that side to the opposing vertex of the triangle. The three altitudes of a triangle intersect at a point called the *orthocenter*.

To calculate the principal point, it is necessary to first identify three mutually perpendicular sets of parallel lines in the scene. Each set of parallel lines has a vanishing point, and together the three vanishing points form a triangle. The orthocenter of this triangle is the camera's principal point, which lies typically at or near the image center.

Figure 1.12 [plate 2] (bottom) shows how an image's principal point can be calculated from three mutually perpendicular sets of parallel lines in the scene. We can safely assume that in the scene the edges on the tiled floor are perpendicular to each other and that they are also perpendicular to the sides of the box, which is resting flat on the floor. The vanishing points for each of these pairs of parallel lines define the vertices of a triangle. To compute the triangle's orthocenter, I have drawn the altitudes of the triangle. The intersection of the three altitudes, the orthocenter, corresponds to the image's principal point.

An example of vanishing line analysis The image of the "SPOT" sign in figure 1.13 [plate 3] is a good example of how vanishing points and lines can be used to reveal a fake. In this image, we can easily identify many pairs of parallel lines that lie within the same plane. For example, the eight sides of the sign provide four pairs of parallel lines. Because the lines at the top and bottom of the sign are nearly parallel in the image, it is difficult to reliably estimate their vanishing point. I computed the vanishing point for the three remaining sides. As expected for an authentic image, the three vanishing points (blue dots) lie on a single line, the vanishing line (red line).

Figure 1.13 [Plate 3] All vanishing points (blue and black) do not converge to the vanishing line (red).

I also computed the vanishing point for the signpost. This vanishing point is not the same as the vanishing point for the left and right sides of the sign probably because the sign is slightly rotated relative to the post. Nonetheless, the sides of the post and the sign lie on parallel planes and so the vanishing point for the post is on the vanishing line for the sign. In contrast, the vanishing points for the stem of the letters "P" and "T" do not lie on the vanishing line (black dots). Although the perspective distortion of the letters looks credible, this geometric analysis reveals the lettering is physically implausible. The image is a fake.

Shadows

Let's now see how the geometry of shadows can be analyzed with lines. A tabloid cover shows two movie stars, rumored to be romantically involved, walking along a beach at sunset. Is the image real or is it a composite created by splicing together images of each actor? The shadows and lighting often hold the answer. Unless the two actors were photographed under identical lighting conditions there may be discrepancies in the shadows and lighting created by different light sources.

A shadow's location provides information about the surrounding light in the scene. These lighting properties should be physically plausible and consistent throughout the scene. We will see how to use an object's shadow to

constrain and reason about the location of the illuminating light source.

Let's start with the simplest situation: a 3-D scene is illuminated by a single, small light source. Consider the scene depicted in figure 1.14 in which a box casts a shadow on the ground. For every point in this cast shadow, there must be a line to the light source that passes through the box: the box is occluding the ground from direct illumination by the light. For every point outside the shadow, there must be a line to the light source that is unobstructed by the box: the ground is directly illuminated by

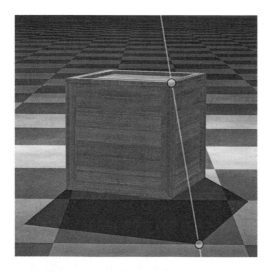

Figure 1.14 A cast shadow constraint connects a point on the box's shadow with the corresponding point on the box.

the light. Consider now a line connecting the point at the corner of the shadow and its corresponding point at the corner of the object. Follow this line and it will intersect the light.

Because straight lines in the physical scene are imaged as straight lines (assuming no camera lens distortion), the location constraint in the 3-D scene also holds in an image of the scene. So, just as the shadow corner, the corresponding box corner, and the light source are all constrained to lie on a single line in the scene, the *image* of the shadow corner, the *image* of the box corner, and the *image* of the light source are all constrained to lie on a single line in the image. This idea is illustrated in figure 1.14, which shows a line that connects a point on the edge of the shadow to the corresponding point on the box. In the image, the projection of the light source lies somewhere on this line.

Now let's connect two more points on the cast shadow to their corresponding points on the object, as shown in figure 1.15. We will continue to use the corners of the box because they are distinctive. These three lines intersect at a single point above the box. This intersection is the projection of the light source in the image.

The geometric constraint relating the shadow, the object, and the light holds whether the light source is nearby (a desk lamp) or distant (the sun). This constraint also holds regardless of the location and orientation of the surfaces onto which the shadow is cast. Regardless of

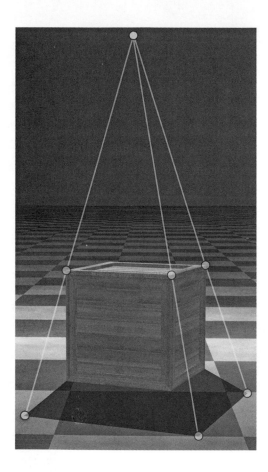

Figure 1.15 All 2-D lines connecting a point on a cast shadow with its corresponding point on the object intersects the projection of the light source.

the scene geometry, all of the constraint lines intersect at the same point.

You will notice that in figure 1.15 I had to extend the boundary of the image plane to see the intersection of the three lines. This is because the light source is not visible in the original image of the scene. This will typically be the case and, depending on where the light is, you may have to extend the lines beyond the image's left, right, top, or (counterintuitively) bottom boundary.

In the above example, the light source is in front of the camera and so the projection of the light source is in the upper half of the image plane. When the light is behind the camera, however, the projection of the light source will be in the lower half of the image plane. Because of this inversion, the shadow to object constraints must also be inverted. The constraints in this case are, therefore, anchored at a point on the object and extend toward the cast shadow.

An example of shadow analysis Let's apply this shadow analysis to one of the most watched YouTube videos of 2012. The video starts with a panning shot of an eagle soaring through the sky. The eagle makes a slow turn and then quickly descends upon a small child sitting on a park lawn. The child's parent is nearby but looking the other way. The eagle snatches the child. As the eagle starts to ascend, it loses its grip and the child drops a short distance

to the ground. At this point, the videographer and parent run to the apparently unharmed child. This video, "Golden Eagle Snatches Kid," quickly garnered tens of millions of viewers who responded with a mixture of awe and skepticism. Were the skeptics right?

The single video frame shown in figure 1.16 [plate 4] is ideal for a shadow analysis because each component of interest (the eagle, the child, and a rich background scene) has a clearly defined cast shadow that was produced by a single light source (the sun).

I performed both a "forward" (light in front of the camera) and "reverse" (light behind the camera) analysis. The "forward" analysis does not yield any consistent light

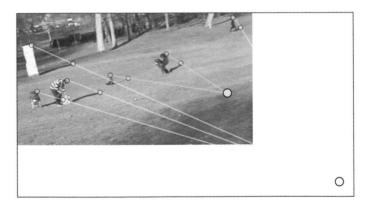

Figure 1.16 [Plate 4] The shadow constraints reveal that there are two distinct light sources in this scene, corresponding to the cyan- and yellow-colored constraints.

source location, while the "reverse" analysis yields an interesting lighting inconsistency. Each "reverse" constraint shown in figure 1.16 [plate 4] is anchored on an object and connects to the object's cast shadow. I've specified six cast shadow constraints, one each for the child and eagle (cyan), and four for the rest of the scene (yellow). Here we see that the four scene constraints have a common intersection in the lower-right corner. The constraints for the child and eagle, however, have a different common intersection. This analysis clearly demonstrates that the lighting in this scene is inconsistent with an outdoor scene illuminated by the sun.

About a week after the video's release, the creators of the video came forward. They were four students at the National Animation and Design Centre in Montreal Canada., who had been told they would receive a grade of A+ if their video received 100,000 views on YouTube. The students acknowledged that the video was a fake: they had composited a computer-generated video of the eagle and child with a choreographed video that had been filmed in the park. This video was not the first clever hoax from the National Animation and Design Centre. "Penguin Escaped Zoo in Montreal" released in 2011 was also a convincing fake. Beware of amazing animal videos from Montreal.

Reflections

Another image phenomenon that is amenable to a line analysis is the geometry of reflections in mirror surfaces.

A photograph of a mirror is the image of an image, and while this is often disorienting to the viewer, the geometry is actually straightforward. This basic geometry holds for the reflections off any flat, mirrored surface such as a window or even a highly polished tabletop. We will see how to determine whether objects and their reflections have the correct geometric relationship. This analysis will provide us with a forensic tool that can be used to test the authenticity of an image that includes reflections in a flat surface.

The basic geometry of a reflection is shown in the schematic in figure 1.17. The schematic shows the relationship between a camera, a mirror (orange), an object (a black pawn), and the object's reflection. A light ray from a point on the pawn is reflected by the mirror to a single point on the camera sensor. At the sensor, these reflected rays are indistinguishable from light rays originating from a pawn located behind the mirror. This virtual pawn and the real pawn are exact mirror images: they are equal in size and equal in distance from the mirror. If we could see this scene from a bird's eye view (as in the lower panel of figure 1.17), we would see that corresponding points on the virtual and real pawns can be connected by parallel lines.

Now let's see how this geometry applies to a more complex scene. Figure 1.18 [plate 5] depicts three boxes reflected in a flat mirror. The lower portion of this figure

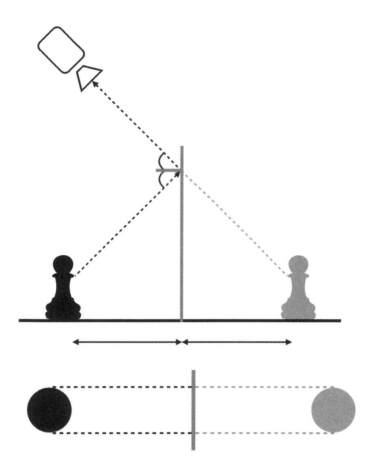

Figure 1.17 The geometry of a reflection. The object (black pawn) is reflected in a flat mirror. Shown below is a top view of the geometry in which corresponding points on the object and reflection are connected by parallel lines that are themselves perpendicular to the mirror.

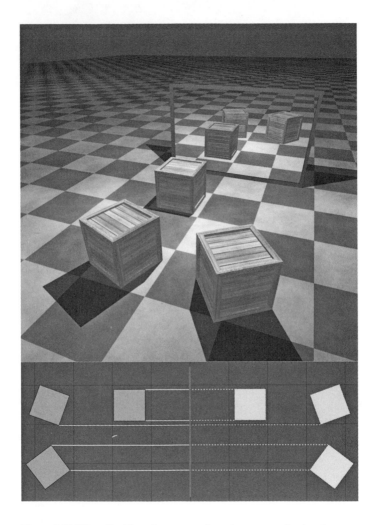

Figure 1.18 [Plate 5] Three boxes are reflected in a mirror (top) and a virtual bird's eye view (bottom) of this scene with the boxes on the left, mirror in the middle, and reflection on the right. The yellow lines connect points on a box to their reflection.

shows the geometric relationship between the real boxes and the virtual boxes. The orange line represents the mirror, which is located at the midpoint between the two sets of boxes. The yellow lines connect corresponding points on the real and virtual boxes. These lines are parallel to each other and perpendicular to the mirror.

The scene geometry changes when the scene is projected onto a camera sensor, as seen in figure 1.19. Lines that were parallel when viewed from the plane of the mirror are no longer parallel. Instead, owing to perspective projection, these parallel lines converge to a single point. Because the lines connecting corresponding points in a scene and its reflection are always parallel, these lines should have a common intersection in the image. If one or more of the lines do not converge on this common intersection, the image may be a fake.

You should notice that this reflection analysis is exactly the same as the vanishing line and cast shadow analysis described above. In the case of shadows, lines connecting points on an object and their cast shadow converge on a common intersection. In the case of reflections, lines connecting points on an object and their reflection converge on a common intersection. Both parallel structures, shadows cast by the sun, and reflections have a simple linear geometry in the scene, which, under perspective projection, manifests itself as a linear constraint in the image. And, both the shadow and reflection constraints are

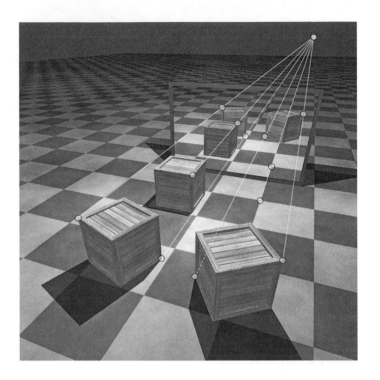

Figure 1.19 Lines connecting any point in the scene with its reflection will intersect at a single point.

a variant of the more familiar concept of vanishing points and lines.

An example of reflection analysis Let's apply this reflection analysis to the photo in figure 1.20 [plate 6], which seems to show one person passing an envelope to

another person. I've identified a number of points on the people and the surrounding building structure that have clearly identifiable reflections. The yellow points and lines correspond to the person facing the camera and the building while the cyan points and lines correspond to the person leaning on the railing. As shown in the bottom of figure 1.20 [plate 6], these constraints do not intersect at a single point, proving that this is a photo composite. If we make the reasonable assumption that the building was in the original image, we can use the constraint lines from the building to determine that the person leaning on the railing was digitally inserted into the photo.

Lens Flare Lastly, let's see how straight lines relate to the films of J. J. Abrams. In this section we will examine how lens flare can be exploited in a forensic analysis.

In a perfect imaging system, light passes through one or more lenses and is focused (refracted) onto a sensor where the image is recorded. In real imaging systems, including the human eye, some light is scattered or reflected rather than focused, and this light gives rise to lens flare aberrations. Lens flare is especially noticeable in images of a bright light like the sun. Although it is generally unwanted by photographers and cinematographers, lens flare may be intentionally created to add dramatic effect. (J. J. Abrams famously used lens flare in the movie *Star Trek* and years later was quoted as saying, "I know there

Figure 1.20 [Plate 6] Shown in the top panel is a composite photo in which the person leaning against the rail (and his reflection) was digitally inserted into the photo. Shown in the middle panel are six reflection constraints (yellow) connecting points on the person facing the camera and parts of the building to their reflection. Also shown are five constraints (cyan) for the person leaning against the railing. As shown in the lower panel, these constraints intersect at different points revealing that the photo is a fake.

are certain shots where even I watch and think, 'Oh that's ridiculous, that was too many [lens flare].' But I love the idea that the future was so bright it couldn't be contained in the frame.")

Lens flare aberrations lie along lines emanating from the center of the light source, and so they can be used to determine the location of the light source in the image. If a scene is illuminated by a single light source (e.g., the sun), then all of the lines delineated by lens flare should intersect at the location of this light source. Any deviations from this common intersection may indicate tampering.

The location of the light source estimated from lens flare can also be compared with the results from other techniques for estimating the light source location. For example, in addition to lens flare, the scene in figure 1.21 [plate 7] contains a cast shadow. Recall that a point on an object, its cast shadow, and the illuminating light source all lie on a single line in the scene. Because straight lines are imaged as straight lines, this observation also holds in the image: a point, its cast shadow, and the light source all lie on a line in the image. Each of the three dashed lines in figure 1.21 [plate 7] connects a corner of the box with its cast shadow. These lines, extended upward, intersect at a single point—the projection of the light source. I've highlighted two components of the lens flare that provide additional constraints on the location of the light source: (1) a line drawn through the center of eight starbursts, and

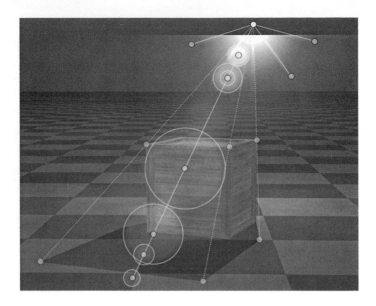

Figure 1.21 [Plate 7] Three cast shadow constraints (dashed lines), three lens flare streak constraints (short solid lines), and a starburst constraint (circles) intersect at the projection of the light source (topmost yellow dot).

(2) short line segments drawn though several streaks. The constraint lines provided by the cast shadows, the starbursts, and the streaks all intersect at a single point, as one would expect for an authentic image illuminated by a single light source.

Example lens flare analysis Did the United States Postal Service really put a mailbox on a desolate snowy

mountain-top as shown in figure 1.22 [plate 8]? Let's take a closer look at this image. The glow of the sun is visible in the upper left corner, and there are two starburst streaks, one running almost horizontally along the top of the image and one running obliquely from the upper-left to the lower-right corner of the image. In figure 1.22 [plate 8], I've drawn a line through the centers of two starbursts on each of these streaks. These lines intersect at the projection of the light source, just slightly outside of the field of view in the upper-left corner of the image. The location of the light source specified by the lens flare seems qualitatively consistent with the shadow on the left-most mountain range and the cast shadow of the mailbox.

Let's look more carefully at the cast shadow. In figure 1.22 [plate 8], I've added a line constraint positioned at the top of the cast shadow and the top of the mailbox. As we discussed earlier, the projection of the light source must lie somewhere on this (infinite) line. We now see an inconsistency: the light source that gave rise to the lens flare does not lie on the line defined by the cast shadow. The lighting in this photo is not consistent with a single sun, indicating that the image is a composite. I created it by digitally inserting the mailbox and its shadow on the desolate mountaintop.

Figure 1.22 [Plate 8] The lens flare streaks constrain the projection of the light source to the small yellow dot in the upper left. The mailbox's cast shadow constrains the projection of the light source to the dotted line. Because these constraints are inconsistent with one another, the lighting in this photo is inconsistent with a single light source.

Pitfalls

Although the analyses of parallel lines, shadows, reflections, and lens flare are all straightforward, they must be conducted with care. Let's look at the considerations one should keep in mind when extracting lines and then extrapolating these lines to their intersection.

Vanishing points can be computed from two or more lines that are parallel in the three-dimensional scene. Many images contain manmade objects with obvious parallel and perpendicular edges that allow vanishing points and principal points to be calculated with confidence. But when such lines cannot be clearly identified, this geometric analysis should not be used.

Similarly, the analyses of shadows and reflections rest on the accuracy of the lines used to test for a common intersection. These lines must connect corresponding points on the object and its shadow or reflection. It is essential to use highly distinctive points so that the correspondence is unambiguous.

Each analysis in this section requires locating an intersection. Although this calculation is straightforward, it may be unstable for lines that are nearly parallel. The distance to the intersection of nearly parallel lines begins to approach infinity, and tiny changes in the selection of the lines can lead to huge variations in the location of the intersection. The most stable and reliable intersections are close to the center of the image.

In the Dark

With troubling frequency, I have been asked by editors of scientific journals to investigate claims of scientific misconduct related to image manipulation. The suspected images are usually of cells or molecular blots, and so the images are devoid of the usual content seen in photographs (people, objects, lighting, shadows, or reflections). In addition, these images are not captured by standard digital cameras. As a result, scientific images cannot be analyzed with many of the forensic techniques described in this book; however, other approaches can be used.

In an authentic image, areas that appear to be uniformly black will, under closer inspection, show some variability. This variability arises because of sensor noise (see Noise) and compression artifacts (see chapter 5, Background). The uniformity of an image area can be tested by enhancing small differences in brightness values across pixels. This enhancement can be done using standard photo-editing software. For example, in Adobe Photoshop this involves first selecting Image → Adjustments → Levels. The Levels panel shown in figure 1.23 allows you to adjust the image *lookup table* that controls the mapping from pixel values (input) to brightness on the display (output).

The first (0) and last (255) values of the Input Levels control the minimum and maximum pixel

Figure 1.23 Adjusting the lightness levels in Photoshop.

value that are mapped to black and white, respectively (as shown in the `Output Levels`). For now, ignore the central input value of 1.00. As the maximum input value is decreased from 255, the lower pixel values begin to span a larger part of the intensity range, and higher pixel values become saturated at white. This expansion of the low pixel values enhances differences in the dark areas of the image.

Figure 1.24 shows an image with the input value of 255 reduced to 128, 64, 32, 16, and 8. (I am showing this for a grayscale image, but the result will be similar for a color image.) As I decrease this value, small differences

Figure 1.24 Adjustment of the upper range of the input levels (from 255 to 8) slowly reveals digital erasure of two cells. (Photo credit [original]: Flickr user Iqbal Osman, https://flic.kr/p/f9m4pi)

in the darker areas of the image become more visible. In the final panel of this figure the pixel values between 0 and 8 are mapped to the entire intensity range from black to white. This mapping reveals two well-defined regions that are uniformly black. Such regions are characteristic of digital erasures: I used photo-editing software to remove the image content in this area. I have found this analysis to be highly effective for finding manipulations in a range of images, but particularly in fraudulent scientific images where this type of erasure is not uncommon.

In the Light

Similarly, we can apply this analysis to areas of the image that appear uniformly white. By increasing the minimum input level from 0 to a value close to 255, we can determine whether a white area is devoid of expected noise, again indicating a digital erasure.

This simple visualization trick can be effective at finding sloppy photo editing, but the sophisticated forger is unlikely to leave behind such obvious traces of manipulation. As such, the lack of this artifact is not evidence that the image is authentic.

Enhancement

One of my most frequent frustrations as a photo analyst is my being asked to enhance low-quality surveillance images or video. These images are often at the heart of criminal investigations because they depict the perpetrator or the perpetrator's car. Unfortunately, the image quality of surveillance cameras is often so low that it is impossible to extract the needed information.

The limitations of surveillance footage may come as a surprise to fans of detective shows in which a handful of pixels is effortlessly transformed into a high-resolution image. In reality, enhancement techniques cannot restore

information that has been lost, but, as I will describe next, they may rectify information that has been distorted.

Imagine photographing a street sign head-on. The image of the sign will accurately reflect the shape of the sign: a rectangle with parallel sides. But when a sign is photographed from an oblique angle, as in figure 1.25, the image will have a distorted shape: the edges of the sign will not be parallel. This *perspective distortion* occurs because the size of an object in an image is proportional to its distance. In the example in figure 1.25, the sign's top left corner is more distant than its bottom right corner, leading to the distortion in the image (see Photogrammetry 101). This perspective distortion is an inevitable consequence of image creation.

In a forensic setting, images often contain critical information that is obscured by perspective distortion. Removal of this distortion can make text on a license plate legible or reveal the length of skid marks on a roadway. In some cases, the removal of perspective distortion can reveal that an image is a fake.

Removing the distortion from an image of an arbitrary object requires knowing the shape of the object. Generally, object shape is unknown and unrecoverable from a single image. A flat planar surface, however, has a known shape—a plane (of course)—and this makes it possible to remove the perspective distortion from an image of a planar surface.

As with the other techniques in this section, the removal of perspective distortion does not require advanced technical skills. In fact, it can be performed in Photoshop with a few simple steps:

1. Load the image into Photoshop (these directions are specified using version CS6).

2. Select *Filter → Vanishing Point*.

3. Select *Create Plane Tool* from the toolbar on the left.

4. Select the four corners of the perspectively distorted rectangular surface in the image.

5. Photoshop will superimpose a gridded plane atop your image (shown in figure 1.25). This is the model of the plane required to remove perspective distortion.

6. Select *Return 3D Layer to Photoshop* from the *Settings and Commands}* menu ▾≡

7. Select *OK*.

8. A new layer will be created that contains a model of the planar surface (shown in figure 1.25). Double click on the *Diffuse* component of the texture layer and the undistorted version of your image will appear in a new window.

Figure 1.25 Removing planar distortion in Adobe Photoshop.

Photoshop removes the sign's perspective distortion in three steps. First, it determines the orientation of the sign relative to the camera. Second, it projects the distorted image of the sign onto a plane at this orientation. And third, it rerenders the plane and the projected image relative to a virtual camera placed directly in front of the sign.

The perspective distortion in figure 1.26 is so severe that it is nearly impossible to read the characters on the license plate. The resulting undistorted image, also shown in figure 1.26, clearly reveals the identity of the license plate. The rectification is obviously not perfect: (1) the top and bottom of the license plate are not visible because the car bumper occludes the top and the plate is bent

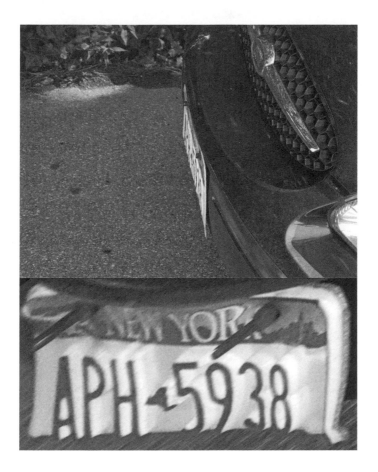

Figure 1.26 Perspectively distorted and rectified license plate.

along the bottom; (2) the sides of the license plate are not straight because the plate is bent at the edges; and (3) the rusted bolts along the top are highly distorted because the bolts protrude from the surface of the license plate. Each of these distortions arises for the same reason—the license plate is not perfectly flat. It is a practical reality that most surfaces are not perfectly flat, and so this type of residual distortion is fairly common. Despite the imperfect rectification, the removal of the perspective distortion is still quite effective at revealing the identity of the license plate.

--

TECHNIQUES REQUIRING INTERMEDIATE TECHNICAL SKILL

This chapter describes five photo-authentication techniques that require basic technical skill but are still straightforward to understand and apply. Although these techniques are relatively accessible, they should be used judiciously. So, in addition to describing how the techniques are implemented, I will also explain the preconditions for their application and the limitations on their interpretation.

The first three techniques involve analyzing properties of the 2-D image. Two techniques leverage the image imperfections introduced by the JPEG compression scheme used by almost all devices. These techniques are described in the sections JPEG Signature and JPEG Ghosts. The third image-based technique, described in Cloning, focuses on a common and powerful form of manipulation in which one

part of an image is copied and pasted into another part of the image to conceal something or someone.

The remaining two techniques in this chapter analyze properties of the objects and scenes depicted in a photo. The first of these techniques, 3-D Facial Reconstruction, uses a photo of a person's face to build a 3-D facial model that can be used to, among other things, estimate the lighting in the scene. The second technique, 3-D Scene Reconstruction, is a more general approach that describes the 3-D reconstruction of other parts of a scene.

JPEG Signature

I distinctly remember the call from Scotland Yard. Under a strong Irish accent, there was a strong sense of urgency and seriousness from the detective spearheading the investigation. A dozen men stood accused of abusing young children and distributing photos of the abuse. At the center of the complex, multiyear case was a series of photographs of unknown origin. The detective asked if I could link the photographs to one of a handful of cameras that had been seized in the investigation. I could. This section describes how I used the JPEG signature embedded in the photographs to determine the make and model of the recording camera. The Noise section in the next chapter describes the technique that I used to identify the specific camera.

A dozen men stood accused of abusing young children and distributing photos of the abuse. At the center of the case was a series of photographs of unknown origin. The detective asked if I could link them to one of a handful of cameras seized in the investigation. I could.

The JPEG (Joint Photographic Experts Group) image format is the standard compression scheme for devices that capture digital images. Compression schemes allow the user to trade-off memory size for visual quality. A highly compressed image requires relatively little memory for storage, but it may have noticeable distortion. A less compressed image will have greater fidelity to the original image, but it requires more memory. Device and software engineers fine-tune this trade-off to suit their individual tastes and needs. In addition, the engineers choose the properties of the thumbnail associated with their product's images as well as how the JPEG metadata is packaged. The resulting variation in JPEG quantization tables, thumbnail properties, and metadata packaging provides a distinctive signature for each type of device.

Because the JPEG signature is so distinctive, it can be used to link an image to a specific camera type. Conversely, when there is a mismatch between an image's signatures and that of the camera that was used to record it, it is reasonable to conclude that the image was resaved after its initial recording. Evidence that an image was resaved does not indicate whether or how it was altered, but it does indicate that alterations may have occurred. This section describes forensic techniques that examine the JPEG signature; for a general tutorial on JPEG compression consult the Background chapter at the end of the book.

JPEG signature I (quantization table)

Decoding a JPEG image requires knowing the quantization values used to encode the image, and so the quantization values must be stored as part of a JPEG file (see Background). The quantization values are specified as a set of 192 integer values organized as three 8 x 8 tables. Each table contains the quantization values for 64 frequencies for one of the three image channels (YCbCr). Because the JPEG standard does not specify the content of the quantization tables, engineers are free to select all 192 values. As a result, quantization tables vary greatly across devices and software. Part of this variation is simply idiosyncratic, but part of it reflects the different compression and visual distortion tolerances for low-, medium-, and high-end cameras. Because these tolerances are constantly being refined, even successive releases of the same camera may use different quantization tables.

The wide variation across JPEG quantization tables is one of the keys to linking an image to a specific camera type. In addition, an image that is edited and resaved acquires the JPEG quantization tables of the editing software. If we can determine that the current quantization tables of an image are not the same as those of the original recording device, this may indicate that the image has been altered. To test whether the image and device quantization tables match, we need the image metadata specifying the make and model of the recording device (see Metadata). We also

need to know the set of possible quantization tables for this device.

For most devices, the range of possible quantization tables can be determined by recording images at all possible pairings of quality, resolution, and, when it is adjustable, aspect ratio. Most devices have a relatively small number of these settings, yielding a small number of possible quantization tables. The tables associated with a particular device can then be compared with the quantization tables of an image purportedly taken with that device.

This image-to-device comparison can be made more specific by including the dimensions of the image. Because the compression settings are often associated with a particular resolution, the quantization table and image resolution may be combined into a single device signature. As described next, this device signature can be honed further by considering the dimensions and quantization tables of the embedded thumbnail (which is stored as a separate JPEG image).

JPEG signature II (thumbnail)
When an image is recorded, most cameras generate a small thumbnail-sized version of the image that is stored in the JPEG file alongside the full-size image. Because of their small size, thumbnails can be quickly read and displayed. This allows operating systems and software programs to

use the thumbnail to provide a quick preview of the full-resolution image.

Thumbnails are typically on the order of 160 x 120 pixels. They are generated from the recorded image in four steps: (1) the recorded image is blurred (this avoids introducing visual artifacts in the next step); (2) the full-resolution image is rescaled to the desired thumbnail size; (3) the rescaled image is optionally sharpened, brightened, and contrast-enhanced; and (4) the thumbnail is saved as a JPEG image. Each of these processing steps requires a number of design decisions. In step 1, engineers must choose a blurring filter. In step 2, they must decide on the dimensions of the thumbnail. When these dimensions have a different aspect ratio from the image, they must decide whether to crop the image or to pad the thumbnail with a black, gray, or white border. In step 3, engineers can optionally select a sharpening filter. And in step 4, they must select JPEG compression settings just as they do for full-resolution images.

Because of the many degrees of freedom involved in generating thumbnails, there is considerable variability in the thumbnails generated by different devices. This variability makes thumbnails useful when testing whether an image has been modified since its initial recording. This forensic technique involves four steps: (1) extract the camera make and model from the image metadata; (2) determine the thumbnail generation parameters for the

device; (3) generate a thumbnail for the image using the estimated device parameters; and (4) compare this new thumbnail with the original thumbnail. If the two thumbnails appear similar and share the same size and compression settings, the image passes this authentication test. If the two thumbnails are visually distinct, the image has been resaved (and possibly modified) after its recording.

The trick to this technique is determining the thumbnail parameters for the device. Manufactures typically do not make such information available, and so recovery of the thumbnail parameters requires reverse engineering the thumbnail generation process. Although I won't describe this more complex process here, I will illustrate the distinctiveness of a JPEG signature from the image and thumbnail JPEG compression settings and dimensions.

Over the past decade I've extracted over 95,000 JPEG signatures using a database of 5,000,000 images from 4,000 devices. These signatures consist of the image and thumbnail dimensions and quantization tables. If we consider only the image components of this signature, 29.1 percent of the signatures are unique to one device; 13.3 percent of the signatures are shared by two devices (in almost all cases, both devices are by the same manufacturer); 7.1 percent, 5.5 percent, and 3.9 percent of the signatures are shared by three, four, and five other devices, respectively. The median number of shared signatures is four and the maximum is 1,340.

If we consider both the image and thumbnail components of the signature, 56.8 percent of the signatures are unique; 18.8 percent of the signatures are shared by only one other device (in almost all cases, a device by the same manufacturer); 7.8 percent, 5.3 percent, and 3.4 percent of signatures are shared by two, three, and four other devices, respectively. The median number of shared signatures is one and the maximum is 191. Increasing the number of details included in a JPEG signature increases the distinctiveness of the signature and decreases its overlap with other devices and software. In many cases, a camera's JPEG signature is sufficiently distinctive to reveal whether an image was taken directly from a particular camera or whether it was modified and resaved after the initial recording.

Some devices dynamically generate quantization tables on a per-image basis yielding hundreds or thousands of possible tables. Such devices can be identified by recording multiple images at the same quality and resolution and verifying that these images are encoded with different quantization tables. Linking an image to this type of device is difficult.

This forensic technique cannot prove that an image is trustworthy. Because some devices and software have a common JPEG signature, a match between an image and a device could be coincidental. In addition, a determined forger can re-encode an altered image with a customized

JPEG encoder that matches the JPEG signature of a specific device. On the other hand, a mismatch between an image and the device that recorded it indicates that the image has been resaved after its initial recording.

JPEG signature III (packaging)
As we've seen, a JPEG image file contains data corresponding to the compressed image and thumbnail as well as their quantization tables. The file may also contain the image metadata. The way these different segments of data are packaged within the file varies across devices and programs, adding to the file details that can link an image to a specific camera type. In addition, an image that is edited and resaved acquires the JPEG data packaging of the editing software. If we can determine that the JPEG packaging of an image is not the same as that of the original recording device, this may indicate that the image has been altered.

Each *data segment* in a JPEG file is labeled with a unique *marker*, as shown in table 2.1. The marker that specifies the quantization tables, for example, is given by the hexadecimal code 0xdb (symbol DQT). This marker specifies the beginning of the data segment that stores the quantization tables that are used to encode, and are needed to decode, the image. Similarly, the marker specifying the Huffman codes used for entropy encoding is labeled as 0xc4 (symbol DHT). Although the JPEG standard

This forensic technique cannot prove that an image is trustworthy. Because some devices and programs use the same JPEG packaging, a match between an image and a device could be coincidental.

Table 2.1. JPEG markers

Code	symbol	Description	code	symbol	Description
0x00	nul	Reserved	0xe7	APP7	application data
0x01	TEM	Reserved	0xe8	APP8	application data
0xc0	SOF0	start frame (B)	0xe9	APP9	application data
0xc1	SOF1	start frame (ES)	0xea	APP10	application data
0xc2	SOF2	start frame (P)	0xeb	APP11	application data
0xc3	SOF3	start frame (L)	0xec	APP12	application data
0xc5	SOF5	start frame (DS)	0xed	APP13	application data
0xc6	SOF6	start frame (DP)	0xee	APP14	application data
0xc7	SOF7	start frame (DL)	0xef	APP15	application data
0xc8	JPG	JPEG extension	0xf0	JPG0	extension data
0xc9	SOF9	start frame (ES)	0xf1	JPG1	extension data
0xca	SOF10	start frame (P)	0xf2	JPG2	extension data
0xcb	SOF11	start frame (L)	0xf4	JPG4	extension data
0xcd	SOF13	start frame (DS)	0xf5	JPG5	extension data
0xce	SOF14	start frame (DP)	0xf6	JPG6	extension data
0xcf	SOF15	start frame (DL)	0xf7	SOF48	start frame
0xc4	DHT	huffman tables	0xf8	LSE	extension parameters
0xcc	DAC	arithmetic coding	0xf9	JPG9	extension data
0xd0	RST0	restart marker 0	0xfa	JPG10	extension data
0xd1	RST1	restart marker 1	0xfb	JPG11	extension data
0xd2	RST2	restart marker 2	0xfc	JPG12	extension data
0xd3	RST3	restart marker 3	0xfd	JPG13	extension data
0xd4	RST4	restart marker 4	0xf3	JCOM	extension data
0xd5	RST5	restart marker 5	0x4f	SOC	start codestream

Table 2.1. (continued)

Code	symbol	Description	code	symbol	Description
0xd6	RST6	restart marker 6	0x51	SIZ	image and tile size
0xd7	RST7	restart marker 7	0x52	COD	coding style default
0xd8	SOI	start image	0x53	COC	coding style component
0xd9	EOI	end image	0x55	TLM	tile-part lengths
0xda	SOS	start scan	0x57	PLM	packet length (main)
0xdb	DQT	quantization tables	0x58	PLT	packet length (tile-part)
0xdc	DNL	number of lines	0x5e	RGN	region of interest
0xdd	DRI	restart interval	0x5c	QCD	quantization default
0xde	DHP	hierarchical pro.	0x5d	QCC	quantization component
0xdf	EXP	expand reference	0x5f	POC	progression order change
0xe0	APP0	application data	0x60	PPM	packet headers (main
0xe1	APP1	application data	0x61	PPT	packet headers (tile-part)
0xe2	APP2	application data	0x63	CRG	component registration
0xe3	APP3	application data	0x64	COM	comment
0xe4	APP4	application data	0x90	SOT	start tile
0xe5	APP5	application data	0x91	SOP	start packet
0xe6	APP6	application data	0x92	EPH	end packet header

specifies that the quantization tables and Huffman codes be stored in segments with these marker names, the standard does not specify the location or the order of these segments in the JPEG file. Camera and software engineers are free to package file data in any way that they choose.

In addition to differences in organization, variants of the JPEG format[1] name the same data segment differently. The marker associated with metadata, for example, is APP0 for JFIF and APP1 for JPEG/EXIF (see Metadata).

For an image file recorded by an iPhone, a typical set of JPEG markers is:

```
SOI APP1 SOI DQT DQT SOF0 DHT DHT
DHT DHT SOS EOI APP1 DQT SOF0 DHT
SOS EOI
```

Notice that there are two pairs of start of image (SOI) and end of image (EOI) markers. The first and last markers bracket the entire JPEG image. The second pair, in the third and twelfth positions, bracket the thumbnail, which is itself stored as a JPEG image. After resaving the image in Photoshop, the JPEG markers are:

```
SOI APP1 SOI APP13 APP14 DQT SOF0
DHT SOS EOI APP13 SOI APP13 APP14
DQT SOF0 DHT SOS EOI APP1 APP2 JPG2
APP14 DQT SOF0 DHT SOS EOI
```

There are a number of obvious differences between the original and Photoshop-generated JPEG files.

1. The file generated by Photoshop has two thumbnails as evidenced by the two sets of start of image (SOI) and end of image (EOI) markers, highlighted below in boldface:

SOI APP1 **SOI APP13 APP14 DQT SOF0 DHT SOS EOI** APP13 **SOI APP13 APP14 DQT SOF0 DHT SOS EOI** APP1 APP2 JPG2 APP14 DQT SOF0 DHT SOS EOI

The first thumbnail is the standard thumbnail regenerated by Photoshop at the time the image is resaved. The second, identical thumbnail is due to what appears to be a Photoshop legacy issue. Before the embedding of a thumbnail became standard practice, Photoshop generated and embedded its own thumbnail. This practice continues today either as a feature or as an oversight. The presence of both thumbnails is further evidence that this file was not generated by an iPhone.

2. In addition to the multiple thumbnails, the presence of the APP13 and APP14 markers denote application-specific data added by Photoshop.

3. Lastly, Photoshop embeds the required thumbnail quantization tables and Huffman codes within one DQT and DHT segment each, while the iPhone uses two DQT and four DHT segments.

Resaving the image in iPhoto also introduces JPEG marker discrepancies:

```
SOI APP0 APP13 APP2 JPG2 APP1 APP1
DQT DQT SOF0 DHT DHT DHT DHT SOS EOI
```

And after resaving the image in Preview, the JPEG markers are:

```
SOI APP0 APP2 JPG2 APP1 APP1 DQT DQT
SOF0 DHT DHT DHT DHT SOS EOI
```

Both iPhoto and Preview strip the thumbnail from the JPEG file. There are other changes as well: the second marker in the original JPEG file is APP1, denoting the beginning of the metadata segment as is consistent with the JPEG/EXIF variant of the JPEG encoding standard. The second marker for the iPhoto and Preview generated files is APP0, also denoting the beginning of the metadata segment. This marker, however, signifies the use of the JFIF variant of the JPEG encoding standard.

We immediately see that these files could not have been generated by an iPhone since it employs a different JPEG encoding standard.

The same camera make and model may yield more than one JPEG data format owing to variations in firmware or in the way the image is exported from the device. In the case of an iPhone, for example, a thumbnail is not embedded when an image is emailed directly from the phone at the lowest resolution. In this case, the JPEG markers will be:

```
SOI APP1 DQT SOF0 DHT SOS EOI
```

instead of a more typical:

```
SOI APP1 SOI DQT DQT SOF0 DHT DHT
DHT DHT SOS EOI APP1 DQT SOF0 DHT
SOS EOI
```

Other variations may include the use of restart segments that divide the compressed image data into independently decodable segments. This allows the JPEG file to be locally decoded in parallel. In this case, the JPEG data after the start of stream marker (SOS) is partitioned into restart segments (RSTn) yielding a third valid set of markers for the iPhone:

SOI APP1 SOI DQT DQT SOF0 DHT DHT
DHT DHT SOS EOI DQT DRI SOF0 DHT SOS
RST0 RST1 RST2 RST3 RST4 RST5 RST6
RST7 RST0 RST1 RST2 RST3 RST4 RST5
RST6 RST7 RST0 RST1 RST2 RST3 RST4
RST5 RST6 RST7 RST0 RST1 RST2 RST3
RST4 RST5 RST6 RST7 RST0 RST1 RST2
RST3 RST4 RST5 RST6 RST7 RST0 RST1
RST2 RST3 RST4 RST5 RST6 RST7 RST0
RST1 RST2 RST3 RST4 RST5 RST6 RST7
RST0 RST1 RST2 RST3 RST4 RST5 RST6
RST7 RST0 RST1 RST2 RST3 RST4 RST5
RST6 RST7 RST0 RST1 RST2 RST3 RST4
RST5 RST6 RST7 RST0 RST1 RST2 RST3
RST4 RST5 RST6 RST7 RST0 RST1 RST2
RST3 RST4 RST5 RST6 RST7 RST0 RST1
RST2 RST3 RST4 RST5 RST6 RST7 RST0
RST1 RST2 RST3 RST4 RST5 RST6 RST7
RST0 RST1 RST2 RST3 RST4 RST5 RST6
RST7 RST0 RST1 RST2 RST3 RST4 RST5
RST6 RST7 RST0 RST1 RST2 RST3 RST4
RST5 RST6 RST7 RST0 RST1 RST2 RST3
RST4 RST5 RST6 RST7 RST0 RST1 RST2
RST3 RST4 RST5 RST6 RST7 EOI

Because a single device may produce a variety of JPEG
marker formats, it is necessary to examine the complete

set of possible formats before concluding that a particular set of markers is or is not inconsistent with the device. If an exhaustive examination does not turn up a match, however, this indicates that the image could have been altered. As with the previous technique, finding a match is not evidence of authenticity. The match could be coincidental as some devices and programs share JPEG marker formats. The match could also have been contrived by the forger to cover her tracks.

Returning to the child exploitation case, I was able to use the distinctiveness of JPEG packaging to uniquely identify the camera make and model used to record a series of photos. As we will see in the Noise section in the next chapter, I was able to further identify the specific camera that was used to take the series of photos at the heart of a complex and troubling case of child exploitation.

This forensic technique cannot prove that an image is trustworthy. Because some devices and programs use the same JPEG packaging, a match between an image and a device could be coincidental. In addition, a determined forger can re-encode an altered image with a customized JPEG encoder that matches the JPEG packaging of a specific device. On the other hand, a mismatch between an image and a device provides strong evidence that the image could have been altered after the initial recording, although it does not reveal the nature of the alteration.

JPEG Ghosts

Sometimes the most mundane cases lead to new forensic insights. I was asked to consult on a seemingly routine trademark dispute that hinged on a photograph produced by the defendant showing the trademarked symbol. Analyses of the photographic image metadata and JPEG signature revealed that the image had been saved by photo-editing software. These analyses could not distinguish between an innocent manipulation, like cropping or contrast/brightness enhancement, and something more nefarious. My intuition was that the photo had been manipulated, and that the trademarked symbol had been digitally inserted. I was suspicious because the region around the symbol appeared to be of lower quality than the rest of the image. The analysis of this photograph eventually led to a new forensic technique that can detect a composite of two images of different qualities.

As we have seen, the JPEG format employs a lossy compression scheme that sacrifices image detail in order to reduce the stored file size (see JPEG Signature). Once an image is compressed, this image detail is irreversibly lost. Opportunely, this loss of information in the image can be a source of information for the forensic analyst.

JPEG quality is specified by a number, often on a scale of 1 to 100, with lower numbers corresponding to less retained information and consequently a smaller file size.

Consider the case where an image is recorded by a camera at quality 50, edited in photo-editing software, and then resaved at the higher quality of 80. Although the image quality is reported to be 80, the information that was discarded at image capture cannot be recovered, and so the effective quality is still 50.

We can uncover discrepancies between the reported quality and the effective quality of an image by assessing the effects of resaving the image at different qualities. If the reported and effective qualities are the same, say 80, then resaving the image at progressively lower qualities will cause a gradual and steady degradation of the image. We can see this gradual degradation by comparing the original image with each of the resaved versions of the image. The simplest way to compare two images is to compute the average absolute pixel value difference between them. As shown in the solid curve of figure 2.1, an image originally saved at 80 will not be altered if it is resaved at this same quality. But if it is resaved at a lower quality, the difference between the image and its resaved version will increase steadily as the resaved image's quality decreases.

Now consider the case of an image that was saved at 50 and then resaved at 80. When this image is resaved again at 80 it will not be altered. But when it is resaved at a lower quality, the difference between the image and its resaved versions will not change in the same steady way

We can uncover
discrepancies between
the reported and
effective quality of an
image by assessing the
effects of resaving it
at different qualities.
If the reported and
effective qualities are
the same, resaving the
image at progressively
lower qualities will
cause degradation of
the image.

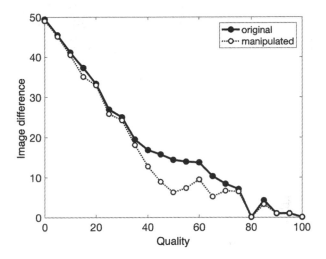

Figure 2.1 The solid and dashed curves each correspond to an image saved at a relatively high-quality of 80. The manipulated image (dashed), however, was previously saved at a lower quality of 50. The difference between each image and recompressed copies of itself show a decidedly different pattern between the manipulated and original. The dip in the image difference at quality 50 is termed the JPEG ghost.

as we saw before. Instead, the difference will level off until we reach the effective quality of the image. Because the effective quality will reveal itself only when probed, we've dubbed it the JPEG ghost.

A JPEG ghost can be uncovered by comparing an image to versions of the image resaved at different JPEG qualities. The simplest comparison is the average absolute pixel value difference between the test image and each of its resaved versions. The dashed curve in figure 2.1 shows

the result of this calculation for an image initially saved at quality 50 and resaved at quality 80. Notice that, after an initial increase, the pixel value difference does not appreciably change until the resaved version of the image reaches a quality less than 50. Compare this with the solid curve, which shows the same function for an image that was never compressed below 80. This ghost of the initial compression is a telltale sign that the image was previously saved at a lower quality.

The presence of a JPEG ghost provides strong evidence that the image could have been altered after the initial recording, although it does not reveal the nature of the alteration.

There are a few limitations to this analysis. First, this analysis is most effective when the edited image is saved at a higher quality than the original image. Second, this analysis works on the assumption that the recompressions that you perform use similar quality settings of whatever photo-editing software was used. Third, this analysis works only if the image was not cropped after editing—that is, if the JPEG block boundaries are preserved. There are more involved techniques for alleviating some of these limitations, but they require more complex computations.

Though it is a bit tedious, this analysis can be performed in Photoshop. The first step is to save copies of the image at each compression level. Then stack these copies in the Layers palette with the original image in

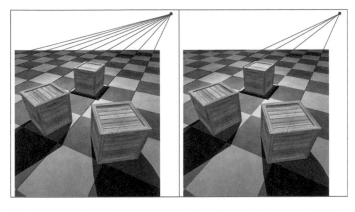

Plate 1
[Figure 1.11]

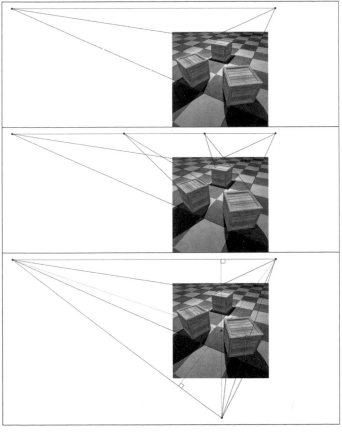

Plate 2
[Figure 1.12]

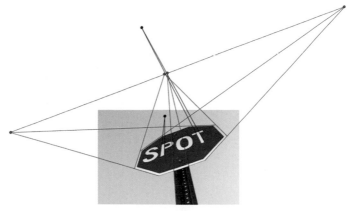

Plate 3 [Figure 1.13]

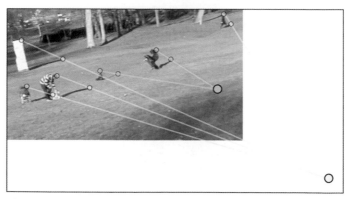

Plate 4 [Figure 1.16]

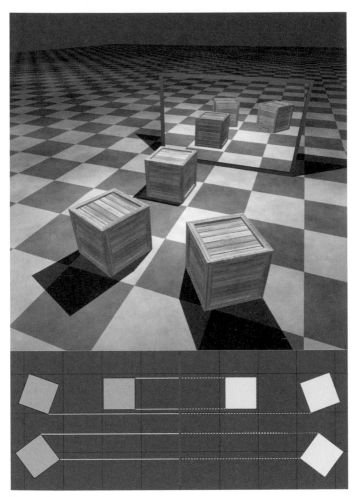

Plate 5 [Figure 1.18]

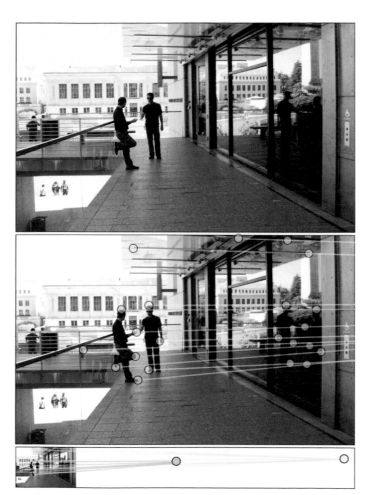

Plate 6 [Figure 1.20]

Plate 7 [Figure 1.21]

Plate 8 [Figure 1.22]

Plate 9 [Figure 2.3]

Plate 10 [Figure 2.4]

Plate 11 [Figure 2.5]

Plate 12 [Figure 2.8]

Plate 13 [Figure 2.9]

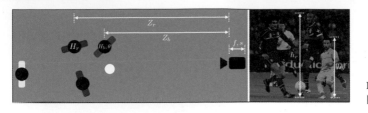

Plate 14
[Figure 2.10]

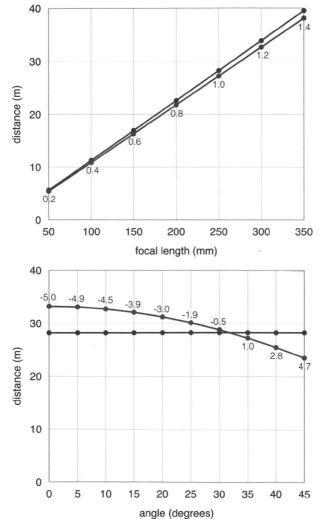

Plate 15
[Figure 2.13]

Plate 16 [Figure 2.18]

Plate 17 [Figure 3.8]

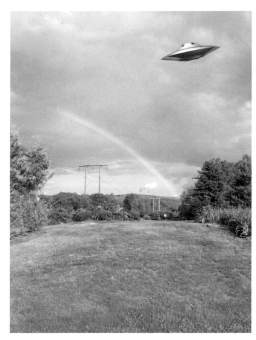

Plate 18 [Figure 3.9]

-0.01 0.0 0.01

Plate 19 [Figure 3.14]

Plate 20 [Figure 3.15]

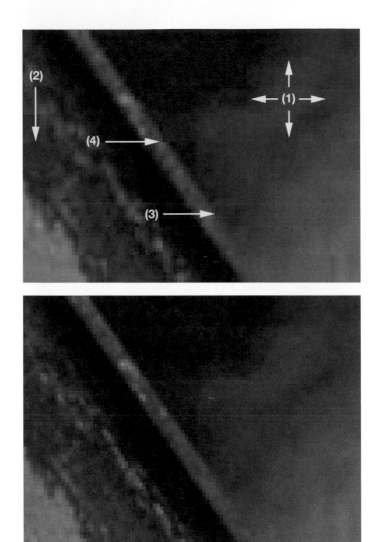

Plate 21 [Figure 5.3]

`Difference` blending mode. The mean pixel value difference can be retrieved from the `Histogram` panel and plotted as a function of the compression level.

Cloning

In 2008, a photo of Iran's provocative missile test appeared on the front page of newspapers around the world. It was quickly revealed, however, that the photo of four airborne missiles had been doctored. To conceal the launch failure of one of the missiles, the image of a successful missile had been copied and pasted over the failed missile. This *cloning* was easily detected because of the suspicious similarity in the billowing dust clouds below two of the rockets. Although the cloning in this image was detectable by eye, carefully executed clones can be imperceptible. This section describes a clone detection analysis that is much more sensitive than the human eye.

Detecting a clone involves two steps: the identification of potential matches, and the verification of a match. The verification step is straightforward: if two regions are clones, their pixel values will be highly correlated. Correlation is a measure of similarity, so if the pixels in the two regions vary in the same way, their correlation will be high. Measuring the correlation in the pixel values of two regions involves a simple computation.

In contrast to the simplicity of verifying matches, the problem of identifying potential matches can easily lead to a combinatorial explosion. To see why this problem explodes, let's assume that we are searching a 1,000 x 1,000 pixel image for a cloned region of known size and shape. An image of this size contains 1,000,000 pixels and yields 500 billion region pairs that must be evaluated.[2] Generally, we do not know the cloned region's size and shape, nor do we know whether the cloned region has been resized or rotated before being added back into the image. Clearly, an exhaustive search of the potential matches in an image is computationally intractable.

With an easy verification step but a prohibitive search space, the task of detecting cloning reduces to finding an efficient and accurate way to search an image for two nearly identical regions. Many algorithms have been proposed; I will describe one that I have found to be both effective and straightforward to implement. The algorithm consists of three basic steps: (1) the identification of distinctive features in the image; (2) the extraction of a compact descriptor of each feature; and (3) the search for two clusters of features that have pairwise similar descriptors and that are related by a translation (and, optionally, a scaling and rotation). Once a potential match has been identified, we then compute the likelihood that the feature clusters correspond to a cloned region in the image. To illustrate these steps in more detail, let's apply them to figure 2.2, which includes a clone of the left-most windmill.

(a) (b)

(c) (d)

Figure 2.2 (a) The original photo; (b) the windmill in the distance has been cloned; (c) a subset of the salient features; and (d) matched features on the original and cloned windmill. (Photo credit [original]: Flickr user Matthew Faltz)

The first step is to identify salient features in the image. These salient features should be sufficiently distinctive that they would have relatively few matches in the image. Clearly, a patch of sky would not be useful. The edge of a windmill blade is also less than ideal because it matches all other points along the edges of the blades. The tips of the windmill blades provide what we need because only a few image locations have a similar local structure.

By focusing our attention on a small set of features we immediately reduce the complexity of our search from the total number of pixels (typically millions) to the total number of features (typically hundreds). To identify the most distinctive features, we quantify their salience using the *Harris detector*. The Harris detector assigns a value to each pixel that is proportional to the amount of spatial variation in the pixels that surround it. A subset of the salient features is shown in figure 2.2 (c).

Once we have identified the salient features in the image, our next step is to describe them in a compact way to allow for efficient matching. This description should retain the distinctiveness of the feature, but it should also be unaffected by common image transformations such as scaling, rotation, brightness and contrast adjustment, and compression. The *histogram of oriented gradients (HOG)* descriptor offers a reasonable compromise between specificity and tolerance to transformations. This descriptor measures the contrast and orientation of localized image structure in a small neighborhood.

The third step in detecting potential matches is to search for two sets of similar features that are related by a translation (and, optionally, a scaling and rotation). Isolating these corresponding sets in a sea of features requires model-fitting in the presence of outliers. In our case, the model is the relationship (translation, scaling, rotation) between the cloned regions. The features associated with

the clone satisfy this model; all other points are outliers. We will employ the *random sample consensus (RANSAC)* algorithm to simultaneously extract the matching features and estimate the relationship between them. The partial results of this algorithm are shown in figure 2.2 (d).

Each of these three main processing steps—*Harris*, *HOG*, and *RANSAC*— are standard image processing algorithms available in libraries such as openCV.

I used the windmill image in figure 2.2 to illustrate this forensic technique because the feature points are easy to identify and the clone is easy to detect. But while we readily perceive symmetries between isolated objects, we are remarkably insensitive to repetitions of a random texture. It is with such textures that our computational technique can easily outperform a human observer. Unless you know exactly where to look in figure 2.2, it is unlikely that you would spot the clone. I removed the sheep in this image by cloning a large portion of the grass from the right side of the image. Although the patches of grass appear nondescript to us, they contain many salient features and our algorithm easily matches the original region with its clone. A subset of these matched features is shown in the lower panel of figure 2.3 [plate 9]. You will notice that just above the cloned rectangular region there is a small patch of grass with three features that have a match under the same transformation as the cloned region. This type of false alarm is not unusual, particularly in extended

Figure 2.3 [Plate 9] An original and altered image (top) and the results of detecting the cloned grass used to remove the sheep (bottom). (Photo credit [original]: Flickr user Karen Roe)

textures. Usually such false alarms can be quickly eliminated by visual inspection when they are small or do not correspond to perceptually meaningful regions of the image.

3-D Facial Reconstruction

Surveillance footage can sometimes give a clear view of a face, but the angle and the lighting may be so extreme that it is difficult to match the surveillance image with a standard mug shot. To make these matches easier, it would be ideal if the mug shots were taken under the same viewpoint and lighting conditions as the surveillance image. Clearly, it isn't feasible to capture all possible viewing conditions when taking mug shots, but it turns out that this isn't necessary. This section describes a technique that can use standard mug shots to render a face under all possible viewing conditions.

The basis for this face rendering technique comes from an influential paper by Volker Blanz and Thomas Vetter entitled "A Morphable Model for the Synthesis of 3D Faces." The paper describes a generic 3-D model that accurately captures a remarkable variety of head shapes and appearances. Most critical, the model has a relatively small number of parameters that can be adjusted to modify the appearance of the face (such as overall size, chin size, location of eyes, and location and size of nose).

The commercially available software FaceGen implements a version of the work by Blanz and Vetter (a trial version is freely available). FaceGen takes as input a frontal profile and side view of a person—a neutral expression and uniform lighting are ideal.

Fiducial markings are manually specified on both images ("+" in figure 2.4). Facegen also works with only a single frontal view, but the 3-D reconstruction is generally less accurate. Once specified, FaceGen automatically estimates the 3-D facial model by modifying the model parameters to best fit the pair of images. Because of the simplicity and versatility of the underlying model, this optimization is relatively fast and accurate. The estimated model, shown in figure 2.4, can be seen to be in good agreement with the originals.

Once estimated, this 3-D model can be fit to any image of the same person, regardless of head pose. Shown in figure 2.5, for example, is an oblique head pose, the model at the same pose, and an overlay of a triangulated version of the model onto the original image (notice that although the model in the middle panel shows the head and neck, this is not part of the estimated model—only the facial region is estimated, and this is then placed onto a generic head and neck). Fitting the 3-D face model to an image of the person involves three steps: (1) a rotation of the 3-D model to the correct pose; (2) a translation of the 3-D model to the correct location; and (3) a projection of the

Figure 2.4 [Plate 10] With a few specified features ("+") from a frontal and side view (top), a 3-D model of the face can be automatically generated (as shown in figure 2.5).

Figure 2.5 [Plate 11] A 3-D model can be oriented to an arbitrary viewpoint and aligned to a photo for comparison: shown from left to right are the person oriented at a ¾ view, the model rotated to this same view, and an overlay of these two views.

3-D model onto the 2-D image sensor to match the appearance of the object in the image. Despite the seeming simplicity of these individual steps, their execution can be difficult. The difficulty arises because of the asymmetry of image formation: the forward projection from 3-D to 2-D is described by equations that are readily solved, but the inverse projection from 2-D to 3-D involves equations that must be solved through a complex optimization (see Photogrammetry 101). An effective technique for performing this alignment is the POSIT algorithm (Pose from Orthography and Scaling with ITerations).

A 3-D face model can be extremely useful in a forensic setting. In addition to the application described above, a 3-D model can also be used to determine if the lighting and shadows on a face are physically plausible. This is

done by positioning a virtual light in the 3-D model of the face until the pattern of lighting and shadows matches the photo in question, or not. This lighting information can also be compared with the shadow analysis described in Lines, Lines, Lines.

3-D Scene Reconstruction

On more than one occasion, I have been presented with a photograph that appears to depict a dubious scene, but a full forensic analysis revealed no evidence of manipulation. Despite not initially finding any traces of manipulation, I was left feeling uneasy about the authenticity of the photo. To dig deeper, I directly examined the aspects of the photograph that seemed suspicious. In this section, I will describe how I used 3-D models to validate the plausibility of several dubious photographs: a utility pole in the middle of a Canadian highway, a bizarrely shrunken football player, and an awkwardly posed presidential assassin.

The case of the pole in the middle of the road

I was sent a photo of a highly improbable scene showing, according to the accompanying caption, a utility pole in the middle of Highway 251 east of Montreal, Canada. I don't mean a downed utility pole; I mean, an upright and

functioning utility pole placed directly in the middle of a highway. That seemed strange, but what made me suspicious of the image was the pole's shadow: it appeared to be either missing or impossibly narrow.

The image and a magnified view of the base of the pole are shown in figure 2.6. From the shading on the pole (brighter on the left and darker on the right) it is clear that the sun is to the pole's left. This suggests that the pole's shadow should be cast to the right. The shadow on the roadway appears to be in the correct direction, but it seems oddly narrow given the width of the pole.

It occurred to me that the pole might have been digitally inserted, that the forger had forgotten to add its shadow, and that the thin black shadow was cast by an overhead cable. Given the simplicity of this scene—a single distant light source, a cylindrical pole, and a planar roadway—it is fairly straightforward to determine if this scene is physically plausible. To test physical plausibility, I look for a 3-D configuration of the scene components that gives rise to the shading and shadows in this image. The goal of this analysis is not to recover the original scene—that is generally impossible given the available information—instead it is to determine whether the image could correspond to a real scene.

A 3-D rendering of the basic components of the above scene is shown in figure 2.7. To generate this image, I made some rough estimates of the camera properties

Figure 2.6 Is this photo of a utility pole in the middle of a road real? The lower panel shows a magnified view of the base of the pole with an oddly narrow shadow.

Figure 2.7 A rendering of my 3-D model of the pole and road (see also figures 2.6 and 2.8 [plate 12]).

because the image metadata was not available. I created a virtual camera with a 50 mm focal length. The camera was placed 18 meters away from the pole and 1.8 meters above the ground plane. I then adjusted the direction of the light until the orientation of the shadow matched. In order to match the width of the shadow, I rotated the ground plane four degrees away from the camera. To determine the alignment of my rendering and the original image, I colored the pole and shadow red and superimposed it atop the original image, as shown in figure 2.8 [plate 12]. In

Figure 2.8 [Plate 12] An overlay of my 3-D rendering (red) and the original photo (see also figures 2.6 and 2.7).

this image, you can see that the pole and shadow are a perfect match.

This 3-D reconstruction is not unique—any number of 3-D scene and camera configurations would have led to the same scene. As discussed elsewhere, there is an inherent ambiguity between the distance to objects in the scene and the camera focal length (see Photogrammetry 101). The point, however, is that a reasonable scene and camera configuration can give rise to the shading and shadows in this image. So, while the configuration that I chose may

not exactly match the real-world scene, it does prove that the scene is physically possible.

It is clear from this 3-D reconstruction that the highly compressed shadow is simply a result of perspective foreshortening. That is, the road is slanted slightly away from the camera and this causes a compression in the cast shadow. We will see a similar effect in the case of the shrunken football player.

The case of the shrunken footballer
The photo in figure 2.9 [plate 13] depicts a 2013 football match between France and Belgium. France's Mathieu Valbuena (right), seems to be absurdly small compared with Belgium players Marouane Fellaini (left) and Vincent Kompany (center). When Reuters released this photo, many thought that it was the result of clumsy photo editing and destined for the "Photoshop Disasters" hall of fame. But Reuters defended the authenticity of the photo, offering this explanation on their website:

> France's Mathieu Valbuena is dwarfed between two Belgium players in this optical illusion photograph which has gone viral online. Valbuena, who is 1.67 m [5 ft 6 in] tall was leaning back at just the right angle when the photograph was captured, which explains why he appears to have momentarily shrunk.

Figure 2.9 [plate 13] Is this photo real or not? The player on the right appears to be impossibly smaller than the surrounding players. (Photo credit: REUTERS/Yves Herman)

Let's look more closely at the photo to see if this explanation is plausible.

Our analysis will determine if there is a physically possible configuration of the players and the camera that could generate the odd proportions in the photo. We'll reconstruct the scene from measurements taken from the photo and from information about the players' heights. We'll have to estimate the likely camera parameters,

however, because the Reuters image did not contain meta-data. But we'll check the sensitivity of the analysis to these parameters.

The schematic in figure 2.10 [plate 14] shows a top view of the football field: France's Valbuena is represented in blue, Belgium's Fellaini and Kompany in red, and the referee in yellow. A camera with focal length f (cm) and sensor resolution s (cm/pixel) is shown on the far right. For now, let's just focus on the players Kompany (red) and Valbuena (blue). The distance between each player and the camera is denoted as Z_r and Z_b, and their heights are denoted as H_r and H_b.

As explained in Photogrammetry 101, the height H (cm) of a person in the scene is related to their height h (pixels) in the image by:

$$H = \frac{shZ}{f}$$

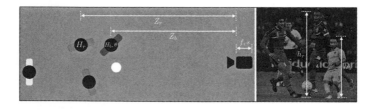

Figure 2.10 [plate 14] A top view of the football field, players, and camera (see figure 2.9 [plate 13]).

where Z (cm) is the distance between the person and the camera, f (cm) is the camera focal length, and s is the resolution of the camera in cm/pixels used to convert the image measurement h from pixels to centimeters. We know from their team profiles that Kompany (red) is 6 ft, 4 in, so H_r = 194 cm, and Valbuena (blue) is 5 ft, 6 in, so H_b = 167 cm. We can easily measure the players' heights in the image: h_r = 1489 pixels and h_b = 1089 pixels.

We do not know the distance Z, the camera focal length f, and the camera resolution s. As a starting point, we can assume that this photo was captured by a telephoto lens, since the photographer would have to be standing on the sidelines. So, we'll use a typical telephoto focal length of f = 25 cm (250 mm). The image width is 2200 pixels and we'll assume a 2.54 cm (1 in) sensor, which is standard for professional-grade cameras. This yields a pixel to cm conversion factor of s = 2.54/2200.

Although we know the height of Valbuena (blue) is H_b = 167 cm, we don't know how far he is leaning back. I'll estimate this angle to be Θ = 35 degrees. Valbuena's effective height in the scene is then simply $H_b \times \cos(\Theta)$; see figure 2.11. With these assumptions and estimates, we can now calculate the distance to each player ($Z = fH/sh$):

$$Z_r = \frac{(25)(194)}{\left(\frac{2.54}{2200}\right)(1489)} = 2821 \text{ cm}$$

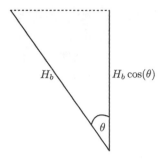

Figure 2.11

$$Z_{br} = \frac{(25)(167\cos(35))}{\left(\dfrac{2.54}{2200}\right)(1089)} = 2720 \text{ cm}$$

Relative to the camera, this places Kompany (red) at 28.2 meters and Valbuena (blue) at 27.2 meters. Given that a typical football field is 68 m by 100 m, these distances seem plausible.

Now let's put these calculations to the test. I've created a 3-D rendering of two characters 28.2 m and 27.2 m from a camera with a focal length of 25 cm. In figure 2.12 (b), both players are standing upright, and their height difference is clear but not exaggerated (Kompany in red is 194 cm, and Valbuena in blue is 167 cm). I then tilted Valbuena backward by 35 degrees and posed each player as they appeared in the original photo, figure 2.12 (a). This rendered scene has the same bizarre appearance

<div style="text-align:center">(a) (b)</div>

Figure 2.12 On the left is a 3-D reconstruction of the scene in figure 2.9 [plate 13], and on the right is the same scene but with the players standing upright.

as the original photo, demonstrating that a plausible 3-D scene geometry can give rise to the odd proportions in this photo.

Our analysis shows that there is a plausible scene and camera configuration that could produce the photo. As a final check, let's take another look at the assumptions we made in our analysis. For each unknown, let's examine how a range of values would affect the outcome of the analysis. The top panel of figure 2.13 [plate 15] shows how different camera focal lengths would affect the estimated distances Z_r and Z_b. Each data point is annotated with the distance between the two players $(Z_r—Z_b)$. The range of focal lengths between 50 mm and 350 mm places the players at distances between 5 and 40 m, with a player-to-player

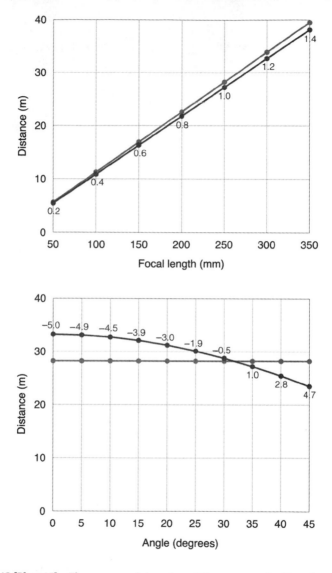

Figure 2.13 [Plate 15] The upper panel shows how different camera focal lengths would affect the estimated distances of Valbuena (blue) and Kompany (red). The numbers below the lines indicate the difference between the two players. The lower panel shows how the estimated distance of Valbuena (blue) would be affected if he was leaning back by different angles Θ. The numbers above the blue line show the distance between Valbuena and Kompany (red line).

separation between 0.2 m and 1.4 m. These distances are all reasonable, and so the plausibility of the photo does not critically hinge on our assumption of a 250 mm focal length.

The lower panel of figure 2.13 [plate 15] shows how the calculated distance between the two players would be affected if we assumed Valbuena (blue) is leaning back by different angles Θ. Here we see that if Valbuena is leaning back by less than 32 degrees, then the scene would require Valbuena to be behind Kompany which is clearly not the case. If, on the other hand, Valbuena is leaning back by an angle between 35 and 45 degrees, then Valbuena would be in front of Kompany by 1.0 m to 4.7 m. These distances seem possible, and so the plausibility of the photo does not critically hinge on our 35-degree assumption.

Reuters's explanation is plausible: the peculiar proportions in this photo are due to the difference in height between Valbuena and Kompany and to the extreme foreshortening of Valbuena in the image. Because Valbuena is leaning back in a direction that is aligned with the camera, the viewer cannot fully compensate for this foreshortening. This leads the viewer to grossly underestimate Valbuena's height in the scene.

The Lee Harvey Oswald backyard photo

John F. Kennedy was assassinated on November 22, 1963. Shortly afterward, Lee Harvey Oswald was arrested and

charged with the crime. Because Oswald was killed before his trial, many questions surrounding the assassination were unanswered, creating fertile ground for conspiracy theories. These theories assert that Oswald was backed by government, international, or criminal groups. As proof, the theorists claim to have discovered discrepancies in the evidence against Oswald. One distrusted piece of evidence is the "backyard" photograph, which shows Oswald in his backyard wearing a holstered pistol and holding a rifle and Marxist newspapers, as seen in figure 2.14. Oswald asserted that this photo had been faked, and conspiracy theorists claim to have found irregularities in the photo that prove Oswald's claim.

The Warren Commission and the House Select Committee on Assassinations investigated claims of photo tampering and concluded that they were unwarranted. But this conclusion has done little to assuage skeptics. Let's take a closer look at the photo and examine four claims made by the skeptics.

The first claim is that there is an inconsistency in the lighting in the photograph. This claim is based on the apparent incompatibility of the shadows cast by Oswald's body and nose. The shadow cast by Oswald's body is fairly long and extends to his right, suggesting a light source located at a low elevation to Oswald's left. The shadow under Oswald's nose extends downward, suggesting an overhead light source (see also figure 2.15). Since the

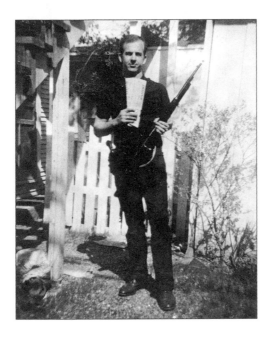

Figure 2.14 The famous "backyard" photo of Lee Harvey Oswald.

photo was captured outdoors, the presence of two light sources would be clear evidence of manipulation, and skeptics have concluded that the photo is a composite of another person's body and Oswald's head. The second claim made by skeptics pertains to the shape of Oswald's face. The claim is that in the photograph, Oswald's chin appears much broader than it does in the mug shot taken upon his arrest (figure 2.15). The third claim is that the rifle in Oswald's hand is shorter than the rifle used to kill

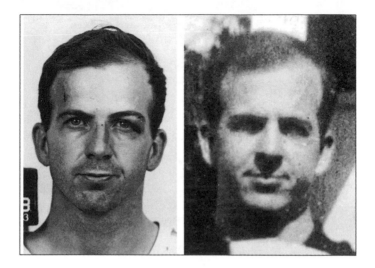

Figure 2.15 Oswald's mug shot (left) and in his backyard (right).

President Kennedy—a 6.5 mm Mannlicher-Carcano. And the fourth claim is that Oswald's stance is not physically plausible given the position of his feet, the manner in which his right leg is bent, and the weight of the rifle that is held in one hand.

To test the first three claims—inconsistent lighting, wrong chin, wrong rifle—we can construct a 3-D model of the scene and compare an image of the 3-D model against the photograph. Our 3-D model used a single light source, biometric information from Oswald's mug shot, and the dimensions of the Mannlicher-Carcano rifle. When

generating an image of the scene, we mimicked the properties of the camera used to take the backyard photograph. If the skeptics are correct, then we should not be able to generate an image that matches the photograph. To test the fourth claim—implausible stance—we added mass to this 3-D model. We then tested whether the model was balanced by determining whether the projection of its center of gravity was contained within its base of support. Again, if the skeptics are correct, we should not be able to find a pose that is both balanced and consistent with the photograph.

3-D model Our 3-D model started with Oswald's nose and chin, two areas critical to the skeptic's claims. We were able to accurately capture the shape of these features using Oswald's arrest mug shots, which captured profile and frontal views. These views are the ideal input for constructing an accurate 3-D model. We used the commercially available software FaceGen (Singular Inversions)—see 3-D Facial Reconstruction. The nose and chin of the model, shown in figure 2.16, are in good agreement with the mug shot. (Note that the top of the head, ears, and neck are generic in shape and not customized to the input images.)

Next, we modeled Oswald's body. We used the open-source tool MakeHuman, which creates 3-D articulated models of the skeleton and skin of the human body. The

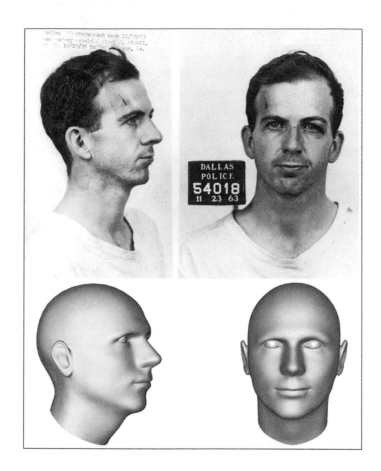

Figure 2.16 A profile and frontal view of Oswald (top), from which a 3-D model of Oswald's face is constructed (bottom).

skeleton represents the main structural components of the body (torso, upper and lower arms and legs, hands, feet, neck, and head). These structural components are articulated by joints that have the appropriate rotational degrees of freedom. The skin is represented by a textured mesh of triangles that overlays the skeleton. The 3-D model can be realistically posed by simply rotating each body part about its joint, while respecting the underlying physiological constraints of the human body (e.g., an arm or leg cannot be made longer or shorter). When moving a body part, the skin is automatically deformed with the skeleton.

We placed a generic 3-D articulated human body with the same height as Oswald (1.75 m) on a ground plane with the feet making direct contact with the ground. We then added a 3-D model of a revolver scaled to the same size as Oswald's revolver, a 0.38 caliber Smith & Wesson (20.0 cm × 14.0 cm × 4.0 cm). We also added a 3-D model of a rifle with the same 1.02 m length as Oswald's Mannlicher-Carcano rifle.

Next, we created a virtual camera that matched the camera used to photograph Oswald—an Imperial 620 Duo Lens camera with 35 mm focal length and 35 mm film size. Using the image produced by the virtual camera as a guide, we manually adjusted the position and pose of the model's head, torso, arms, and legs to match Oswald's appearance in figure 2.14.

Lighting Because Oswald is standing outdoors, modeling the light source was straightforward. We could safely assume a single dominant light source—the sun—which can be modeled as a point light source. We manually positioned the light until Oswald's cast shadow on the ground and the shadows on his face and body matched those in the original backyard photo. This process required iterative adjustments of the geometry and the light position to match the original photo. The results are shown in figure 2.17.

An illustration of the alignment of the 3-D model and the original photo is shown in figure 2.18 [plate 16].

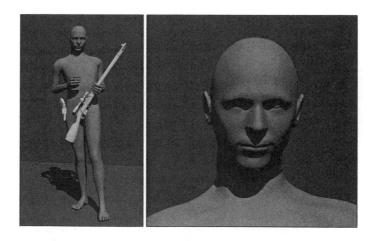

Figure 2.17 The posed 3-D model of Oswald and a magnified view of his head.

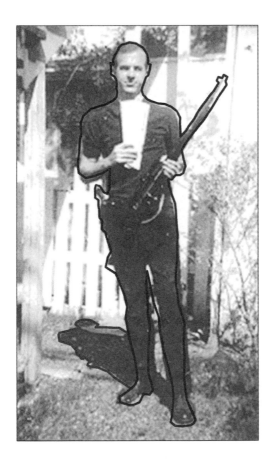

Figure 2.18 [Plate 16] An overlay of our 3-D model and the original photo. The blue outline corresponds to Oswald's body and the red outline corresponds to Oswald's shadow.

The outline of the 3-D model (blue) and its cast shadow (red) are superimposed atop the original image, showing a nearly perfect match.

With an illuminated 3-D model, we can evaluate three of the skeptics' claims about the backyard photo: (1) despite our initial intuition, we see in figure 2.17 that the shadows cast by Oswald's body and nose are consistent with a single light source; (2) Oswald's chin appears broader than it does in the mug shot simply because of the shading on either side of his chin; and (3) the rifle in the photograph is consistent with a 1.02 m rifle; the same length as the Mannlicher-Carcano rifle used to assassinate Kennedy.

I do not claim to have produced an exact 3-D model of the background scene; there may be a number of 3-D geometries that are consistent with the 2-D image. Instead, I claim to have proven that a physically plausible 3-D scene could give rise to the backyard photograph.

To investigate the skeptics' fourth claim, that Oswald's stance is unbalanced, we need to add 3-D mass to the 3-D model.

Balance To analyze the 3-D stability of Oswald's stance, we needed to add mass to the skeleton. Oswald weighed (64.4 kg).[3] We distributed this weight across the model by dividing the body into fourteen segments and assigning each segment a mass in the same proportions

as an average male human body. The body segments and mass proportions were: head (6.94%), trunk (43.46%), upper-arms (2 × 2.71%), forearms (2 × 1.62%), hands (2 × 0.61%), thighs (2 × 14.16%), shins (2 × 4.33%), and feet (2 × 1.37%). The fractional masses were distributed along the length of each segment and then consolidated at the segment's center of mass as shown in figure 2.19. The weights of the Mannlicher-Carcano rifle (3.4 kg) and the Smith & Wesson revolver (1.0 kg), were assigned to the centers of mass of the respective firearms in the 3-D model.

By simply summing up the centers of mass for the body segments, rifle, and pistol, we can compute the model's overall center of mass. This overall center of mass is projected onto the ground plane in the direction of gravity. The 3-D center of mass (central dot) and its projection onto the ground plane are shown in figure 2.20. If this projected center of mass is contained within the base of support, the 3-D model is stable.

The base of support is computed as the *convex hull* of all points on the 3-D model that are in contact with the ground. Since we assumed that the ground is a plane, the convex hull is a 2-D polygon. A polygon is a convex hull if it fully contains the line segments between any two points within it. The base of support is shown in figure 2.20 along with the 2-D projected center of mass. The projected center of mass lies well inside of the base of support. Despite

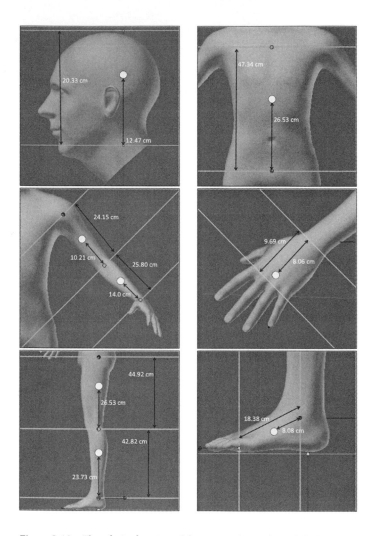

Figure 2.19 The relative location of the center of mass for each body segment (dot).

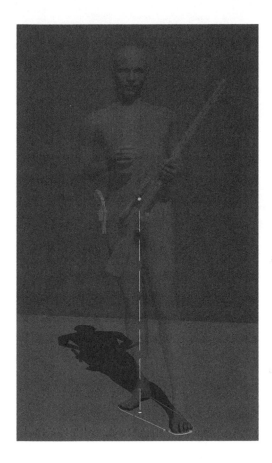

Figure 2.20 Oswald's center of mass (dot) is projected to the ground plane (dotted line). Because this projection is contained within his base of support (polygonal region), Oswald is stable.

the seemingly strange angle of his legs, Oswald's pose is stable.

At first glance, several features of the Oswald backyard photo seem implausible, but a 3-D model of the scene demonstrates that these features are entirely credible. Despite previous claims, there are no inconsistencies in Oswald's shadow, appearance, or pose. This analysis does not prove that the photo is authentic, but, if it is not authentic, it is a perfectly crafted, fully 3-D-consistent forgery created more than 50 years ago. That seems implausible.

TECHNIQUES REQUIRING ADVANCED TECHNICAL SKILL

This chapter describes five techniques for authenticating a photo that require a high level of technical sophistication to implement. Although the techniques are advanced, they are explained in a way that should make them understandable to any interested reader.

The first section, Double Compression, describes a technique for detecting whether an image has been resaved after the initial recording. The next two sections, Color Filter Array and Resampling, exploit subtle pixel patterns in the image that result from, respectively, how an image is recorded by a modern-day sensor and from a specific but common form of photo manipulation. The fourth section, Noise, describes a technique that leverages two forms of imperfections introduced by cameras, one of which is particular to an individual camera and another that is present, in varying degrees, in all cameras.

Throughout this book, I have described the process of authenticating an image of a real scene photographed with a real camera. In the last section of this chapter, Computer-Generated Content, I will describe the creation and analysis of photographs that are generated by a computer rendering or machine-learning algorithm.

Double Compression

When storing an image, most devices apply JPEG compression to reduce the amount of memory required. JPEG compression is a mixed bag for a forensic analyst: it can destroy the evidence contained in color filter array patterns (see Color Filter Array), sensor noise (see Noise), and resampling (see Resampling), but it also leaves clues in the image metadata (see Metadata and JPEG Signature). In this section, we will see that JPEG compression can also leave cues in the image itself. When an image is compressed more than once, it may contain subtle but distinctive anomalies that distinguish it from a JPEG image that was directly recorded. The double compression indicates that the image was resaved after its initial recording, leaving open the possibility that the image has been altered by image-editing software.

Before we examine the effects of double JPEG compression, let's first look at the process of compression.

JPEG compression reduces the amount of memory needed to store an image through the process of quantization (see JPEG Signature). To quantize a value c by an amount q, we divide c by q and round down[1] to the nearest integer (e.g., $c = 8$ quantized by $q = 3$ is $8/3 = 2.66$, which rounds down to 2). An example of quantization is shown in figure 3.1. In the top panel is the original distribution of values, which cover the range of 0 to 11. In the lower panel is the result of quantizing these values with $q = 3$. The shaded gray areas indicate how each value in the initial distribution is transformed. For example, the lower bin, labeled 1, collects all of the values in the initial bins 3, 4, and 5 because $3/3 = 1$, $4/3 = 1.33$, and $5/3 = 1.66$ and each of these values rounds down to 1. Because the compressed histogram contains less information, it requires less memory to store it.

When a compressed image is reopened, it is decompressed. Ideally, decompression would restore the original values, but this is impossible after quantization because once values have been pooled they cannot be resegregated. Instead, the information is rescaled to restore the range of the original values. To continue with our example, rescaling would involve multiplying the quantized values by $q = 3$ to restore them to something close to the original range of 0 to 11. These new values are a coarser version of the original values.

Figure 3.1 Quantization by a factor of 3.

Now let's examine the nature of the information that is quantized during JPEG compression. The original image contains three color channels (RGB), with each channel showing the spatial distribution of that color in the image. Before the image is compressed, the RGB channels are converted into three luminance/chrominance channels (YCbCr) (for details about this step and subsequent steps see chapter 5, Background). Each YCbCr channel is then partitioned into nonoverlapping 8 × 8 pixel blocks, and each block is subjected to a discrete cosine transform (DCT). This DCT recodes the 64 pixels of the block as 64 spatial frequencies.[2] The element in the first row and first column of the block, the (1,1) element, is the value of the lowest frequency (referred to as the DC-term), the

remaining values are referred to as the AC-terms, and the (8,8) element corresponds to the highest frequency. The DCT preserves all of the information in the original image, but it represents it in a way that allows perceptually salient information to be preserved during compression.

The values for each spatial frequency are collected from all of the blocks in the image and quantized separately. Since there are 64 spatial frequencies within each of the three chrominance/luminance channels, JPEG compression involves $64 \times 3 = 192$ separate quantizations, each with its own quantization value q. As we've discussed in another section (JPEG Signature), the values for q are selected based on aesthetic and technical considerations, and they vary considerably across devices and programs. Typically, q is larger for high frequencies than for low frequencies because we are less sensitive to high frequencies. Similarly, q is larger for the chrominance channels than the luminance channel because we are less sensitive to chrominance. In general, JPEG compression is designed to discard image information that is perceptually inconspicuous.

With this background, we are ready to consider the effect of double compression. Figure 3.2 shows the distribution of DCT values for each the following stages: (a) initial values, (b) after quantizaton with $q = 3$, (c) after rescaling, and (d) after a second quantization with $q = 2$. The shaded gray areas in panel (d) for bins 1 and 3 show how these

Figure 3.2 Double quantization by a factor of 3 followed by a factor of 2 are shown in panels (a)–(d). Single quantization by a factor of 2 is shown in panel (e).

values are transformed by the first quantization, the rescaling, and the second quantization. Note that in the final distribution (d) bins 2 and 5 are empty. This shouldn't be surprising because we initially condensed 12 bins into four and then later expanded the range to five bins. After bins have been condensed, subsequent transformations can only shift the values of the bins; they cannot reverse the pooling of values. As a result, after the second quantization, two of the final six bins are empty.

For comparison, panel (e) of figure 3.2 shows the original distribution after a single quantization with $q = 2$. This singly compressed distribution has the same number of bins as panel (d), but the content of the bins is strikingly different. Unlike the double compression distribution, the single compression produces no empty bins. The anomalous distribution after double compression is the telltale sign that the image was recompressed after the original recording. As we will see in more detail below, anomalous distributions are not unique to a double quantization with $q = 3$ followed by $q = 2$.

We will now examine the full range of anomalous distributions produced by double compression. We can denote the quantization of a DCT value c by an integer value q_1 using the round down, or *floor*, function:

$$\left\lfloor \frac{c}{q_1} \right\rfloor$$

Upon decompression, a quantized value is returned to its original scale by multiplying by the quantization value:

$$\left\lfloor \frac{c}{q_1} \right\rfloor q_1$$

And then upon resaving, a second quantization by q_2 is applied:

$$\left\lfloor \left\lfloor \frac{c}{q_1} \right\rfloor \frac{q_1}{q_2} \right\rfloor$$

where q_2 may or may not be the same as q_1. The relationship between these two quantization values determines the severity of the anomaly introduced by double compression. There are three basic possible relationships to consider: (1) the first compression quality is higher than the second: $q_1 < q_2$; (2) the first compression quality is lower than the second: $q_1 > q_2$; and (3) the first and second compression qualities are equal: $q_1 = q_2$ (for the first two cases, we should consider whether q_1 and q_2 are integer multiples of each other or not; for simplicity, however, I will assume that they are not).

Case 1: $q_1 < q_2$
In this case, the first compression quality is higher than the second. To illustrate this case, let's set $q_1 = 2$ and $q_2 = 3$.

With these quantization values, the values $c = 0, 1, 2, 3$ each map to $\hat{c} = 0$:

$$\left\lfloor \left\lfloor \frac{0}{2} \right\rfloor \frac{2}{3} \right\rfloor = \left\lfloor (0)\frac{2}{3} \right\rfloor = \lfloor 0 \rfloor = 0$$

$$\left\lfloor \left\lfloor \frac{1}{2} \right\rfloor \frac{2}{3} \right\rfloor = \left\lfloor (0)\frac{2}{3} \right\rfloor = \lfloor 0 \rfloor = 0$$

$$\left\lfloor \left\lfloor \frac{2}{2} \right\rfloor \frac{2}{3} \right\rfloor = \left\lfloor (1)\frac{2}{3} \right\rfloor = \left\lfloor \frac{2}{3} \right\rfloor = 0$$

$$\left\lfloor \left\lfloor \frac{3}{2} \right\rfloor \frac{2}{3} \right\rfloor = \left\lfloor (1)\frac{2}{3} \right\rfloor = \left\lfloor \frac{2}{3} \right\rfloor = 0$$

Only the next two consecutive values $c = 4, 5$ each map to $\hat{c} = 1$.

$$\left\lfloor \left\lfloor \frac{4}{2} \right\rfloor \frac{2}{3} \right\rfloor = \left\lfloor (2)\frac{2}{3} \right\rfloor = \left\lfloor \frac{4}{3} \right\rfloor = 1$$

$$\left\lfloor \left\lfloor \frac{5}{2} \right\rfloor \frac{2}{3} \right\rfloor = \left\lfloor (2)\frac{2}{3} \right\rfloor = \left\lfloor \frac{4}{3} \right\rfloor = 1$$

The next four consecutive values $c = 6, 7, 8, 9$ each map to $\hat{c} = 2$.

$$\left\lfloor \left\lfloor \frac{6}{2} \right\rfloor \frac{2}{3} \right\rfloor = \left\lfloor (3)\frac{2}{3} \right\rfloor = \lfloor 2 \rfloor = 2$$

$$\left\lfloor \left\lfloor \frac{7}{2} \right\rfloor \frac{2}{3} \right\rfloor = \left\lfloor (3)\frac{2}{3} \right\rfloor = \lfloor 2 \rfloor = 2$$

$$\left\lfloor \left\lfloor \frac{8}{2} \right\rfloor \frac{2}{3} \right\rfloor = \left\lfloor (4)\frac{2}{3} \right\rfloor = \left\lfloor \frac{8}{3} \right\rfloor = 2$$

$$\left\lfloor \left\lfloor \frac{9}{2} \right\rfloor \frac{2}{3} \right\rfloor = \left\lfloor (4)\frac{2}{3} \right\rfloor = \left\lfloor \frac{8}{3} \right\rfloor = 2$$

The pattern continues with even values of \hat{c} pooling four initial values and odd values of \hat{c} pooling only two initial values. This corresponds to the uneven distribution shown in figure 3.3.

Figure 3.3 The results of double quantization by a factor of 2 followed by a factor of 3.

Case 2: $q_1 > q_2$

In this case, the first compression quality is lower than the second. For example, let's consider the case when $q_1 = 3$ and $q_2 = 2$. With these quantization values, the values $c = 0, 1, 2$ each map to $\hat{c} = 0$:

$$\left\lfloor \left\lfloor \frac{0}{3} \right\rfloor \frac{3}{2} \right\rfloor = \left\lfloor (0)\frac{3}{2} \right\rfloor = \lfloor 0 \rfloor = 0$$

$$\left\lfloor \left\lfloor \frac{1}{3} \right\rfloor \frac{3}{2} \right\rfloor = \left\lfloor (0)\frac{3}{2} \right\rfloor = \lfloor 0 \rfloor = 0$$

$$\left\lfloor \left\lfloor \frac{2}{3} \right\rfloor \frac{3}{2} \right\rfloor = \left\lfloor (0)\frac{3}{2} \right\rfloor = \lfloor 0 \rfloor = 0$$

Similarly, the next three consecutive values $c = 3, 4, 5$ each map to $\hat{c} = 1$:

$$\left\lfloor \left\lfloor \frac{3}{3} \right\rfloor \frac{3}{2} \right\rfloor = \left\lfloor (1)\frac{3}{2} \right\rfloor = \left\lfloor \frac{3}{2} \right\rfloor = 1$$

$$\left\lfloor \left\lfloor \frac{4}{3} \right\rfloor \frac{3}{2} \right\rfloor = \left\lfloor (1)\frac{3}{2} \right\rfloor = \left\lfloor \frac{3}{2} \right\rfloor = 1$$

$$\left\lfloor \left\lfloor \frac{5}{3} \right\rfloor \frac{3}{2} \right\rfloor = \left\lfloor (1)\frac{3}{2} \right\rfloor = \left\lfloor \frac{3}{2} \right\rfloor = 1$$

Now something interesting happens for the next set of consecutive values c = 6, 7, 8:

$$\left\lfloor \left\lfloor \frac{6}{3} \right\rfloor \frac{3}{2} \right\rfloor = \left\lfloor (2)\frac{3}{2} \right\rfloor = \lfloor 3 \rfloor = 3$$

$$\left\lfloor \left\lfloor \frac{7}{3} \right\rfloor \frac{3}{2} \right\rfloor = \left\lfloor (2)\frac{3}{2} \right\rfloor = \lfloor 3 \rfloor = 3$$

$$\left\lfloor \left\lfloor \frac{8}{3} \right\rfloor \frac{3}{2} \right\rfloor = \left\lfloor (2)\frac{3}{2} \right\rfloor = \lfloor 3 \rfloor = 3$$

Notice that the value \hat{c} = 2 was skipped because no values in the original distribution map to a value of 2. This pattern repeats: the values c = 9, 10, 11 map to \hat{c} = 4 and c = 12, 13, 14 map to \hat{c} = 6 so no values map to \hat{c} = 5. Thus a double quantization with q_1 = 3 and q_2 = 2 produces a final distribution in which every third bin is empty, figure 3.4.

Case 3: q_1 = q_2
In this case the two compression qualities are the same. Let's consider the case when q_1 = q_2 = 2. The values c = 0, 1 each map to \hat{c} = 1, the values c = 2, 3 each map to \hat{c} = 2, and the values c = 4, 5 each map to \hat{c} = 3. This pattern continues with an exact 2-to-1 mapping of initial to doubly quantized values, figure 3.5. Because of this consistent

Figure 3.4 The results of double quantization by a factor of 3 followed by a factor of 2.

Figure 3.5 The results of double quantization by a factor of 2 followed by a factor of 2.

mapping, the distribution for this double quantization is indistinguishable from a single quantization. Unlike the previous two cases, when $q_1 = q_2$, the distribution of values does not contain a detectable anomaly.

Whether double compression produces detectable anomalies in the distribution of a DCT value depends on the relationship between the first and second quantization values. As we have just seen, cases 1 and 2 produce anomalous DCT distributions that are easily detected, while case 3 produces DCT distributions that are difficult to distinguish from those produced by single compressions. JPEG compression involves 192 separate quantizations ($192 = 8 \times 8$ frequencies times 3 channels) each with its own quantization value q. We will see below that only a fraction of these quantizations will be useful for our analysis, but we require only one anomalous distribution to detect double compression.

Although I will not provide a proof that these patterns persist for a wide range of quantization values, it is easy to empirically verify their presence by following the same series of steps enumerated above.

The anomalous pattern caused by multiple compressions is repeated across the entire distribution of DCT values. In some cases, this periodic pattern is as simple as a populated bin followed by an unpopulated bin as happens, for example, when $q_1 = 2$ and $q_2 = 1$. In other cases, this periodic pattern is a bit more complex. For example, with

$q_1 = 5$ and $q_2 = 2$ the anomalous pattern is one populated bin, followed by two unpopulated bins, followed by one populated bin, followed by one unpopulated bin. This pattern of five then repeats. Regardless of the specific pattern, the detection of double compression is based on the presence of a periodic pattern in the distribution of DCT values.

When analyzing a JPEG image for traces of multiple compression, we can use any of the 64 spatial frequencies in any of the three luminance/chrominance channels. The nine distributions in figure 3.6 correspond to spatial frequencies (1,1) through (3,3) of the luminance channel of a singly compressed image. The (1,1) distribution—the DC-term—corresponds to the mean of each 8×8 pixel block and it has a qualitatively different distribution than the remaining distributions, which are highly peaked at 0 and have long tails. The distributions for the higher spatial frequencies are especially peaked. (Because high spatial frequencies correspond to abrupt transitions in the image this distribution means that most locations in natural images do not contain sharp edges or lines.) These distributions are peaked to begin with, and because the high spatial frequencies are heavily quantized, many values are pooled to 0, further exaggerating this peak. The nine distributions in figure 3.7 correspond to a doubly compressed version of the same image, where $q_1 > q_2$. In each histogram, you can clearly see the telltale

Figure 3.6 Nine distributions of a singly compressed image. Each panel corresponds to one of 64 possible spatial frequencies in a 8 × 8 DCT block.

sign of double compression: a distinct periodic ripple in the distribution. Generally, the presence of an anomalous distribution of DCT values is obvious from visual inspection.

Because high spatial frequencies are usually heavily quantized, their distributions tend to have little content beyond the large peak at the origin. As a result, these higher frequencies provide little data for detecting the periodicity produced by multiple compressions. For this

Figure 3.7 Nine distributions of a doubly compressed image. Each panel corresponds to one of 64 possible spatial frequencies in a 8×8 DCT block. The periodic and unequal distribution of values are the result of double compression.

reason, I typically focus my analysis on the frequencies (1,1) through (3,3), as in figures 3.6 and 3.7. Similarly, the chrominance channels tend to be quantized by larger amounts than the luminance channel, so I start my analysis with the luminance channel.

Once the distribution of DCT coefficients are displayed the ripple produced by double compression is so distinctive that further analysis is generally unnecessary.

What makes this analysis challenging is the need to extract the DCT coefficients from the JPEG file. Any software that you use to view an image decompresses the image, converting the DCT coefficients to pixel values. Custom software is, therefore, required to extract the DCT coefficients, one frequency and channel at a time.

This analysis is highly sensitive to double compression, but it does require that the image remain in perfect registration between the first and second compression. If the image is cropped or transformed (e.g., scaled or rotated) between the compressions, there may be a misalignment between the original and subsequent 8×8 DCT sampling lattice. Any misalignment between the underlying DCT values will eliminate the anomalies that arise from multiple compressions.

The detection of multiple compressions does not reveal what happened to the image after its recording. But it does reveal that the image was resaved, and this leaves open the possibility of manipulation. On the other hand, the absence of multiple compression anomalies does not guarantee that the image was not resaved. This is because certain pairings of double quantization do not lead to anomalous DCT distributions and cropping or transforming the image before the final compression will destroy the anomalous distributions.

Color Filter Array

The sensor of a modern digital camera is a marvel of engineering. From its invention in 1969, the digital camera sensor has undergone remarkable advances. Beyond improvements in quality and resolution, perhaps the most impressive advance involves miniaturization. This miniaturization, however, has required some clever engineering, the results of which can be forensically exploited.

To understand the design of camera sensors, it is useful to understand the design of the eye's sensor, the retina. The human retina contains two types of photoreceptors, rods and cones. Although the rods greatly outnumber the cones (100 million to 5 million), the center of the retina where vision is most detailed consists entirely of cones. Rods function under dim illumination when sensitivity to light is critical. Cones function under moderate to bright illumination and encode detailed information about the location and wavelength of light. The information about wavelength that is encoded by the cones gives rise to our perception of color. Remarkably, we are able to distinguish some 10 million colors from just three wavelength measurements, each made by a different type of cone. The three cone types, L-cones (long), M-cones (medium), and S-cones (short), are named for the wavelength of light[3] to which they are most sensitive.

Analogous to the eye's three cone types, digital cameras have three channels with different peak sensitivities: R (red), G (green), and B (blue). This means that each pixel in a digital image is represented as three values: R, G, and B. A typical 24-bit digital image allocates eight bits (2^8 = 256 distinct values) to each of three color channels. This gives rise to 2^{24} = 16,777,216 distinct possible colors, on a par with the human eye.

The camera sensor is sensitive to all visible light. To measure the light in one color channel it is necessary to restrict the wavelength of the light that impinges on the sensor. This restriction is accomplished by a *color filter array (CFA)* that sits atop the sensor. Most CFAs use a Bayer pattern as shown in figure 3.8 [plate 17]. The color of each square in the pattern indicates the part of the visible spectrum (R, G, or B) that the filter transmits at that location. The Bayer pattern has twice as many G filters as R or B filters because it is designed to mimic the human retina, which is most sensitive to light in the green range of the spectrum. Unlike the human retina, the R, G, and B filters of the CFA are distributed in a consistent, periodic pattern. This periodicity is important because it is the key to our next forensic technique.

Note that the CFA transmits only one part of the visible spectrum to each cell on the sensor. For a full-color image, it is necessary to have all three measurements for each pixel. Since each sensor cell makes only one measurement,

Figure 3.8 [Plate 17] Bayer pattern.

the other two values must be reconstructed. This process—
CFA interpolation—reconstructs the missing RGB values
by interpolating the surrounding values. Consider, for
example, the cell in the second row and second column
in the Bayer pattern shown in figure 3.8 [plate 17]. This
sensor cell measures the R-channel, but not the G-channel
or B-channel. Values for the G-channel are measured by

cells immediately above, below, and on either side of it. We can make a reasonable guess about the missing G-channel value from an average of its four neighbors. This basic process underlies all CFA interpolation algorithms.

As a result of CFA interpolation, two-thirds of all RGB values have been reconstructed by interpolating neighboring measurements. And, because the CFA pattern is periodic, the interpolation introduces periodic correlations between these values. These periodic correlations are highly distinctive, and so their presence provides a reliable sign that the image is authentic.

The correlations introduced by CFA interpolation are so subtle that they are imperceptible. To detect the correlations, we must employ a statistical technique. Extracting these correlations would be relatively straightforward if all devices used a Bayer pattern CFA and the same CFA interpolation process. But they do not. So, while we know that a periodic subset of color values will be correlated with their neighbors, we don't know which pixels will be correlated, nor do we know the form of these correlations. We seek to determine both.

Each pixel in an image is either: (1) directly recorded by the sensor and therefore unlikely to be precisely correlated with its neighboring pixels; or (2) not directly recorded by the sensor and therefore precisely correlated with its neighboring pixels as a result of CFA interpolation. If we knew which pixels were directly recorded, and which

were not, then it would be straightforward to determine the nature of pixel correlations resulting from CFA interpolation. On the other hand, if we knew the mathematical nature of the pixel correlations resulting from CFA interpolation (e.g., every interpolated pixel is equal to the average of its four neighboring pixels), then it would be straightforward to determine which pixels satisfied this correlation and which did not.

In either case, knowing one piece of information allows us to infer the other. In our case, however, we do not know either and must therefore resort to applying a statistical data-fitting algorithm—*the expectation/maximization (EM) algorithm*—to simultaneously determine both pieces of information. Because this algorithm is fairly complex, I will not describe it in detail. In essence, the EM algorithm calculates for each pixel the probability that it is correlated with its neighboring pixels.

In an authentic image, the pattern of pixels that are correlated with their neighbors should follow the Bayer (or similar) pattern in figure 3.8 [plate 17]. For example, if we analyze the green channel, then the camera will directly record every other pixel and the remaining pixels will be interpolated and therefore highly correlated with their neighbors. To see how this works, consider the image in figure 3.9 [plate 18] and the results in figure 3.10 of performing a CFA analysis on the green channel of this image. Because of the high resolution of the image, it is

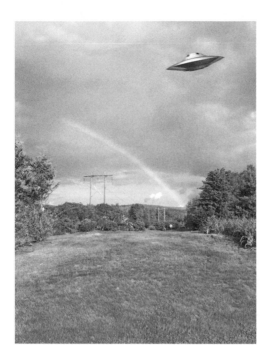

Figure 3.9 [Plate 18] Is the UFO real or not? See figure 3.10 to find out.

difficult to see the periodic pattern without magnifying the image (as I have done in the inset), but it is easy to see the lack of the periodic pattern in the area around the UFO that I added to an otherwise original image. As you can see in the magnified inset, although the pattern of correlations is highly regular it does not exactly follow the Bayer pattern. This is primarily because the JPEG compression

Figure 3.10 The UFO was added to the image as can be seen from the lack of color filter array (CFA) correlations (see also figure 3.9 [plate 18]).

weakens the correlations a bit, but not so much that they still can't be measured and verified.

CFA interpolation will be detectable only in images that meet certain requirements. First, the image must have been recorded and maintained at the maximum sensor resolution. Because CFA interpolation operates on a neighborhood of only a few pixels, the introduced

correlations will be destroyed if an image is resized either by the camera during recording or by editing software afterward. Second, the image must not have been heavily JPEG compressed. Because of the lossy nature of JPEG compression, the fine-grained, pixel-level correlations may be destroyed by significant JPEG compression. As a general rule, a CFA analysis will be ineffective for JPEG qualities less than 85 percent. Third, simple manipulations like overall changes to brightness or contrast are unlikely to disrupt the CFA interpolation, and are therefore unlikely to be detectable.

Although large-scale manipulations of the image would destroy the CFA correlations, a forger could reinsert these correlations in each color channel. This counterattack requires knowledge of the camera CFA pattern and CFA interpolation, but this is certainly not out of the reach of a sophisticated forger. In this regard, stronger conclusions can be drawn from the inconsistencies in the CFA correlations.

Resampling

Tall fish tales are probably as old as fishing itself, but in the digital age, these exaggerated tales can now be accompanied by an exaggerated photo. Using photo-editing software, I was able to inflate the fisherman's catch in

figure 3.11 by isolating the fish from its background and stretching it. To stretch this region of the image, the software simply redistributes the pixel values of the original area over the larger area. Because there are not enough original values for every pixel in the larger area, the software must fill in the missing values. This filling-in process uses the values of neighboring pixels to fill in the missing values using one of a few standard *interpolation* algorithms (this interpolation is typically specified as nearest neighbor, bilinear, or bicubic interpolation).

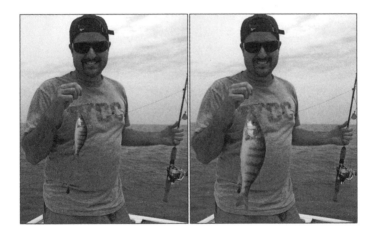

Figure 3.11 An original (left) and manipulated photo (right) in which the fish was isolated and digitally enlarged. (Photo credit [original]: Flickr user Geoffrey Halliday)

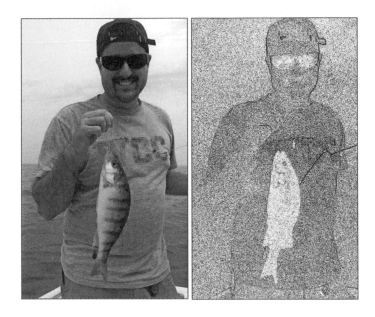

Figure 3.12 An altered image in which the fish has been enlarged and the result of analyzing the image for traces of resampling.

A small-scale example of interpolation is shown in figure 3.13. The numeric values in a 3 × 3-pixel area correspond to the brightness levels of a grayscale image. To vertically stretch this area to a size of 5 × 3, we first evenly distribute the existing pixel values across the larger area (rows 1, 3, 5). We then interpolate the missing values for each of the pixels in rows 2 and 4 (shaded gray) using the average value of the pixel's nearest two vertical neighbors

Figure 3.13 A small-scale example.

(e.g., the first element of the second row, 5, is the average of its northern and southern neighbor, 4 and 6).

This interpolation process is required whenever an image patch is enlarged, reduced, or rotated. And while interpolation usually creates no obvious perceptual artifacts, it does produce a highly specific pattern of pixel relationships that is unlikely to occur naturally. In this example, the unnatural artifact is that every pixel of every other row is an exact average of its two vertical neighboring pixels.

This section describes the nature of these interpolation artifacts and a computational algorithm that can automatically detect them.

The correlations introduced by resampling interpolation are so subtle that they are imperceptible. To detect the correlations, we must employ a statistical technique, as we do to uncover similar patterns from color interpolation (see Color Filter Array). What makes both tasks difficult is that we don't know which pixels (if any) will be correlated with their neighbors nor do we know the form of these correlations. We seek to determine both.

Each pixel in an image is either (1) an original pixel and unlikely to be precisely correlated with its neighboring pixels, or (2) the result of interpolation and therefore precisely correlated with its neighboring pixels. If we know which pixels are resampled, it would be straightforward to determine the nature of pixel correlations resulting from interpolation. On the other hand, if we know

the mathematical nature of the pixel correlations resulting from resampling, it would be straightforward to determine which pixels satisfy this correlation and which do not.

In the previous section, we faced a similar problem when searching for the correlations introduced by CFA interpolation. In both cases we knew we had two sets of pixels, one with original values, the other with interpolated values, but we didn't know which pixels were which, nor did we know the nature of the interpolation. To solve for both unknowns simultaneously we use statistical data-fitting algorithm called *expectation/maximization (EM)*. The details of the EM algorithm are beyond the scope of this book, but the upshot is that the EM algorithm calculates the probability that each pixel is correlated with its neighboring pixels.

The expectation/maximization algorithm returns the estimated interpolation parameters that describe the relationship between a subset of pixels and their neighbors and the probability that each pixel belongs to this subset. This probability, ranging between 0 and 1, can be visualized as a grayscale image. The probabilities for the manipulated photo in figure 3.11 are shown in figure 3.12. In the image on the right, brighter pixels correspond to higher probabilities. You can clearly see that the pixels corresponding to the resized fish have an overall high probability of being predicted by their neighbors. It is not immediately clear,

however, that these predictable pixels are periodic, as we would expect if they are a resampling artifact (a secondary analysis based on a *Fourier* analysis is required to reveal the periodic pattern).

Individual color channels may contain artifacts from color filter array (CFA) interpolation that may confound a resampling analysis (see Color Filter Array). Converting a color image to grayscale will eliminate these CFA artifacts while preserving the resampling artifacts. Because resampling interpolation operates on a neighborhood of only a few pixels, the relationship between an interpolated sample and its neighbors is easily disrupted by subsequent manipulations such as JPEG compression. As a general rule, a resampling analysis may not be effective for images with JPEG qualities below 90 percent. A forger could obscure resampling artifacts by adding a small amount of noise to a manipulated image (see Noise). For this reason, the absence of resampling artifacts provides inconclusive evidence regarding the authenticity of an image, while the presence of resampling artifacts in a region of an image clearly indicates tampering.

Noise

Most often, photo-forensic analysts are called upon to analyze images for traces of tampering. Occasionally, the

issue is not the authenticity of an image but rather its provenance. You might recall that this issue was central to the child sex abuse case that was mentioned in the section JPEG Signature. In this case, a group of men in the United Kingdom was accused of sexually abusing children and globally distributing images of the abuse. Much of the evidence in the case hinged on determining whether the pornographic images were all taken with a device belonging to one of the defendants. One technique for establishing provenance involves examining whether the noise pattern in the images, which, we will see, serves as a kind of watermark for the camera sensor. (This technique extends that of JPEG signature, which can link an image to a particular camera make and model.)

A digital camera contains a vast array of sensor cells, each with a photo detector and an amplifier. The photo detectors measure incoming light and transform it into an electrical signal. The electrical signals are then converted into pixel values. In an ideal camera, there would be a perfect correlation between the amount of light striking the sensor cells and the pixel values of the digital image. Real devices have imperfections, however, and these imperfections introduce noise in the image.

One source of noise is stray electrons within the sensor cell. These stray electrons combine with the electrons generated by the photo detector as it responds to light. The resulting noise pattern is random, fluctuating from

Most often, photo-forensic analysts are called upon to analyze images for traces of tampering. Occasionally, the issue is not the authenticity of an image but rather its provenance.

image to image (more about this soon). A second source of noise has different characteristics. This noise arises from slight variations in the size and material properties of the sensor cells themselves. Physical inconsistencies across the sensor cells lead to differences in the efficiency with which the cells convert light into digital pixel values. These variations, termed *photo-response non-uniformity (PRNU)*, lead to a stable noise pattern that is distinctive to the device.

Although the PRNU will leave a trace in any image, it is easiest to see in a blank image like that of a cloudless sky. If the sky is perfectly uniform, then an ideal camera with an array of identical sensor cells would produce an image that is perfectly homogeneous. In contrast, a real camera will produce an image that has a faint speckle pattern. The speckle occurs because some sensor cells over-report the amount of incoming light, while others under-report it. If the average sensor cell multiplies the amount of light by a factor of one, the over-reporting sensor cells multiply it by a factor slightly greater than one, and the under-reporting cells multiply it by a factor slightly less than one. Unlike sensor noise, which modulates the pixel regardless of its value (see below), PRNU modulates the pixel proportional to its value. Also, unlike sensor noise, PRNU is a fixed property of the sensor and does not vary from image to image.

The PRNU associated with a particular device is not just stable; it is also distinctive. Even devices of the same make and model have different PRNUs. The stable and distinctive properties of the PRNU allow it to serve two forensic functions. The PRNU can be used to determine whether a particular image is likely to have originated from a given device. The PRNU can also be used to detect localized tampering in an image that was taken from a known device. This second use allows us to confirm the authenticity of an image taken by a photographer who has already produced a body of trusted work.

The estimation of the PRNU relies in part on the distinctive statistical properties of noise, which are unlike the statistical properties of normal image content. It is possible to get a crude estimate of a device's PRNU from a single image, but a reliable estimate requires 10 to 20 images (the exact number depends on the quality of the camera, as well as the quality and content of the images).

I estimated the PRNU of my iPhone using 20 images of largely uniform texture-less scenes such as the sky and a blank wall. A small 64 × 64 pixel region of the PRNU is shown in figure 3.14 [plate 19]. From the scale at the bottom of this image, you can see that the PRNU factor typically lies between –0.01 and 0.01 (meaning that it only modulates the recorded pixel value by 1 percent).

-0.01 0.0 0.01

Figure 3.14 [Plate 19] A portion of the photo response non-uniformity (PRNU) pattern for my iPhone camera.

I then used my iPhone to photograph a group of students on the Dartmouth College campus. To measure the similarity between this image's PRNU and the device's PRNU, I performed a simple pixel correlation. In this case, the resulting correlation value was 0.073. Given that a perfect match would yield a value of 1.0, this correlation may seem too low to provide insufficient evidence of a match.

To test whether a value of 0.073 is sufficient to link the image to my iPhone, I used the photo-sharing website Flickr to randomly select 100,000 images that were the same size as the iPhone image. I then compared the PRNU extracted from each image with the PRNU of the iPhone. The median similarity for these images was 0.0056, more than an order of magnitude smaller than that of the image recorded by the iPhone. Of the 100,000 images I tested, 98.4 percent had a correlation value less than 0.02, 99.9 percent had a value less than 0.03, and 99.99 percent had a value less than 0.04. (The maximum similarity value was 0.0428.) Even though the image PRNU and iPhone PRNU were only weakly correlated, this correlation was sufficient to link the two with high confidence.

To have this level of confidence in a match between an image and device, it is essential to have an accurate estimate of the device PRNU. This subtle pattern is best estimated from a collection of largely uniform images (e.g., images of a clear sky or a blank wall). If uniform images

are not available, then any collection of original images can be used, provided the collection is large enough to compensate for the lack of uniformity. Although the number of required images will vary depending on the quality of the sensor, this number can be determined by gradually adding images to the estimate of the PRNU pattern until there is no appreciable change between successive estimates. All of the images used to estimate the PRNU must have the same resolution, the same orientation, and, ideally, the same JPEG quality. Similarly, a device PRNU can be compared only with an image PRNU of the same resolution, the same orientation, and similar JPEG quality.

While a PRNU match is fairly conclusive, a failure to match is less conclusive. The PRNUs may fail to match because one or both of the PRNU estimates is inaccurate. In addition, if an image is not at the highest resolution or is heavily JPEG compressed then the PRNU will be largely obliterated and this forensic analysis will be of limited use. If the image being analyzed has been cropped, it will be necessary to search the device PRNU for the region that corresponds to the cropped image. This search involves sliding the image PRNU across the device PRNU, one pixel at a time, and finding the location that produces the largest correlation between the two patterns.

A second forensic technique leverages a different type of sensor noise. In addition to the stable form of noise just

described, there is a second source of sensor noise that varies randomly from image to image. This noise originates from many sources including stray electrons, that is, electrons that were not generated in response to light. The number of stray electrons increases with ambient temperature, camera exposure, and the camera ISO setting.[4] When the sensor is exposed to light, the stray electrons combine with those generated by the photo detector, causing slight variations in the final pixel values. Unlike the *multiplicative* nature of PRNU, sensor noise *sums* with the photo detector signal, and can therefore be modeled with a pixel-wise *additive* modulation.

Imagine that we point our camera at a perfectly uniform gray wall. A noise-free sensor will record an image with the same value at each pixel. Let's say that this pixel value is 128 (a pure black pixel has a value of 0 and a pure white pixel has a value of 255). Stray electrons and other sources of sensor noise modulate the value of each pixel by adding a small positive or negative value to 128. From pixel to pixel, the amount of modulation varies randomly with a range that depends on temperature, exposure, and ISO. Because these factors can vary across images, the modulation range typically varies from image to image. These factors do not vary within an image, however, so the overall level of noise should be the same throughout an authentic image.

When creating a photo composite, it is common to combine multiple images. If the sensor noise in these source images is not the same, the level of noise in the composite will vary across space. Resizing (see Resampling), sharpening, or blurring a region within an image may also create variation in the level of noise across the image.

Estimating noise is difficult. A recorded pixel value is the sum of two numbers: the amount of measured light and the amount of noise. What are the two numbers? This problem is under-constrained as there are many pairs of numbers that produce the same sum. For example, if I told that you that a pixel value is 72, there is no way for you to know whether the noise-free pixel value is 71 and the noise is 1, or the noise-free pixel value is 70 and the noise is 2. We therefore approach the problem of noise estimation probabilistically and ask, for each image pixel, what is the most likely noise-free pixel value given the observed noisy pixel value. This approach requires making some assumptions about the statistical properties of natural images and sensor noise. The details of this technique are fairly complex and beyond the scope of this book. The point is that significant inconsistencies in the estimated noise across an image may be the result of tampering.

Like all techniques, this noise analysis requires careful interpretation. If a region of the image is saturated

(maxed-out at black or white in one or more color channels), then the noise in this region will have been obliterated. These regions should be ignored when analyzing sensor noise. While an inconsistency in the sensor noise of an unsaturated image is a red flag, a lack of inconsistency is inconclusive. A forger could remove the sensor noise from the original image, alter the image, and then re-insert the sensor noise. This counterattack requires access to effective noise-removal software, but it is certainly not out of the reach of a sophisticated forger. In addition, this forensic analysis is ineffective with images that have been significantly reduced in resolution (more than a factor of four) or heavily JPEG compressed (quality less than 50 percent) because both of these manipulations obscure sensor noise.

Computer-Generated Content

In the early 1980s it was illegal in New York State for an individual to "promote any performance which includes sexual conduct by a child less than sixteen years of age." In 1982 Paul Ferber was convicted under this law for selling material that depicted underage children involved in sexual acts. Ferber appealed, and the New York Court of Appeals overturned the conviction, finding that the obscenity law violated the First Amendment of the US Constitution.

The US Supreme Court, however, reversed the appeal finding that the New York State obscenity law was constitutional. The court argued that the government has a compelling interest in preventing the sexual exploitation of children and that this interest outweighs any speech protections.

The landmark case of *New York v. Ferber* made it illegal to create, distribute, or possess child pornography. The ruling, backed by significant law enforcement efforts, was effective and by the mid-1990s, child pornography was, according to the National Center for Missing and Exploited Children (NCMEC), largely a "solved problem." By the early 2000s, however, the rise of the internet brought with it an explosion in the global distribution of child pornography.

In response to the growth of the on-line distribution of child pornography, the United States Congress passed in 1996 the Child Pornography Prevention Act (CPPA), which made illegal "any visual depiction including any photograph, film, video, picture or computer-generated image that is, or appears to be, of a minor engaging in sexually explicit conduct." This was a significant expansion of the original law because it proposed to outlaw content that did not directly involve or harm an actual child.

In 2002, the CPPA was challenged in the US Supreme Court case of *Ashcroft v. Free Speech Coalition* on the grounds that the CPPA was overly broad and thus created

an unintentional ban on protected speech. The Court agreed and classified computer-generated child pornography, the creation of which does not involve an actual child, as protected speech. As a result, a defense attorney need only claim that her client's images of child pornography are computer generated and thus protected material. The burden of proof then falls on the prosecutor to prove that the images are in fact real (photographic). The ability to distinguish between protected (computer generated) material and illegal (photographic) material, therefore, has become essential to prosecuting child pornography crimes.

Until fairly recently, computer-generated content (also referred to as *computer-generated imagery [CGI]*) was created by constructing three-dimensional models of people, objects, and scenes, illuminating these models with virtual lighting, and then rendering the resulting scene through a virtual camera. This type of technology has been used to make animated movies like *Toy Story* and *Frozen* and is also commonly used in live-action movies to create some of the most stunning special effects, ones that are simply impossible to create with live actors. More recently, advances in machine learning have led to new techniques for creating CGI content. These techniques forgo three-dimensional modeling and rendering, and instead leverage massive image and video sets to synthesize images and videos. While not yet perfect, this technology has the potential to create undetectable fakes.

Although we may enjoy being fooled by CGI humans at the cinema, it is imperative that we be able to distinguish between real and rendered humans in courtrooms and elsewhere. One new technique that can make this distinction exploits the tiny periodic fluctuations in skin color that occur with each heartbeat. These changes are not captured by CGI because they are visually imperceptible. But a remarkable group of MIT researchers[5] has shown that this type of tiny fluctuation can be enhanced to make it more visible. Paired with some standard face-detection and tracking technology, video magnification can be used to determine whether or not a person in a video has a pulse.

The four frames in the top row of figure 3.15 [plate 20] are of a motion-magnified video in which the person was staring into the camera. In these motion-magnified frames, you can see the change in facial color from green to red. The plot below these frames shows the average facial color over the entire video. As expected, the change in facial color is synced to the pulse. On the other hand, the four frames in the bottom row of figure 3.15 [plate 20] are of a motion-magnified video of a computer-generated person. In these motion-magnified frames and the corresponding plot, you can see that there is no pulse.

As with all forensic analyses, it is probably just a matter of time before the adversary adapts and introduces an artificial pulse into computer-generated content. This, in

Figure 3.15 [Plate 20] Shown in the top row is a visualization of the change in blood flow resulting from the human pulse. Also shown is a plot of the color changes in the person's face (vertical axis) as a function of time (horizontal axis), revealing the presence of a periodic pulse. No such physiological signal is present in the computer-generated face shown in the bottom row.

turn, will require us to develop new forensic techniques that expose other inconsistencies in computer-generated content. This, of course, will again be countered by the adversary, and so on and so on.

CLOSING REMARKS

The digital age has created a number of knotty dilemmas. This book focuses on one of these: we rely on photographs, but we cannot entirely trust them. The field of digital forensics attempts to separate a photographic fact from fiction by looking for evidence of photographic tampering. Having reviewed a number of these techniques, we can draw some general conclusions. Dozens of techniques can detect photo tampering and new techniques are constantly being developed. Taken as a whole, these techniques look for signs of tampering in the image metadata, pixel statistics, imaging artifacts, and image content. Many of the signs of tampering are imperceptible to the human eye. The sheer number, variety, and subtlety of these techniques make it difficult (but not impossible) for a forger to completely elude detection.

Some digital forensic techniques can uncover clear evidence of tampering. Other techniques can reveal the possibility of tampering by showing that an image was resaved after it was recorded. No technique can prove authenticity. In general, authentication is simply a failure to find evidence of tampering. Highly skilled forgers may be aware of various authentication techniques and may be able to elude detection. For this reason, claims of authenticity are never absolutely certain.

How easily a forger can conceal evidence of tampering depends on both the format and content of the image. Because some images are easier to fake than others, some negative results are more meaningful than others. An experienced analyst will consider the characteristics of a photo when judging how much weight to give a negative result.

Although some forensic techniques require little technical skill, all of the techniques require careful application and judicious interpretation. It is imperative to understand the conditions that must be satisfied for a technique to produce reliable results.

Tampering is most evident in high-resolution and high-quality images that have intact metadata. For this reason, an image that is intended to serve as documentation (for example, in a court of law or in a news outlet) should be recorded at the highest possible resolution and quality and not pass through any post-processing that might

cause the image to be modified or stripped it of its metadata (this includes passing through photo-management software or a social-media platform). Even minor modification (such as cropping or contrast enhancement) should be avoided because it leaves open the possibility of other forms of editing.

Although we have focused primarily on detecting tampering in photos, the field of photo forensics is much broader. It includes techniques that can, for example, build a three-dimensional model of a face from an image, rectify image details to make them decipherable, or link photographs to a particular camera.

Despite significant advances over the past two decades in the field of photo authentication, much works remains to be done. While many of the techniques described in this book are highly effective, many of them require manual oversight to apply them. This means that they require some expertise and that they are not yet ready to be deployed at internet-scale (to the tune of millions to billions of uploads a day).

We in the authentication business are in the same cat-and-mouse game as those fighting spam and computer viruses. As we develop techniques for authenticating digital images, those intent on manipulating digital images continue to adapt. These adaptions include new techniques aimed to circumvent detection as well as more sophisticated techniques for creating fake content. Advances in

machine learning (ML), in particular, pose a new and considerable threat. Such ML-based techniques can, with only a sample audio of a person talking, synthesize a recording in the person's own voice saying just about anything. Similar ML-based techniques can, with only a sample image or video of a person, synthesize a video of the same person moving their head, eyes, and mouth as if controlled by a puppet-master. Combine these two technologies and it is possible to generate a convincing fake video of a world leader saying whatever you want them to. Perhaps the most powerful aspect of these new technologies is that the machines are automatically generating this content. As a result, someone with little skill can quickly generate a video forgery that surpasses what only the most skilled animators could do just a short time ago. Fortunately, ML-generated content is almost certain to leave behind traces of its origins and so new authentication techniques can be developed to expose this latest form of fakery.

It is my hope that as photo authentication techniques continue to be developed and refined, these tools will be broadly deployed to help us all contend with sorting out the real from the fake. In addition to these advances, we as a society must insist on other changes. First, social media giants must take more responsibility for abetting the proliferation of conspiracy theories and fake news (for an especially tragic example look no further than the devastating violence in Myanmar and Sri Lanka, which has been

fueled by fake news stories and calls to violence on Facebook and other social-media platforms). This will entail a fundamental rethinking of the perverse incentives for promoting sensational and controversial content simply because it engages users. We as a community should continue to pressure social-media companies to rein in the abuses on their platforms. Second, as countries around the world are wrestling with the serious and, at times, deadly consequences of misinformation, many legislative bodies are contemplating legislation on how to contend with these phenomena. While some forms of legislation may be appropriate, we need to be exceedingly cautious that any legislation not stifle vigorous and open debate and hinder future innovations. And third, we as consumers have to get smarter and more critical of what we read and see. We need to get out of our echo chambers and engage with facts and reality in a less partisan and myopic way. While I expect that forensic techniques will continue to play a role in sorting out the real from the fake, we as consumers of digital content should also shoulder some of that responsibility.

BACKGROUND

Many of the forensic techniques build on either general properties of photography or on specific properties of digital images. While I will try to explain each technique in basic and understandable terms, some readers may find it helpful to start with an overview of these properties. The first section of this overview shows how a simple algebraic expression relates the location of objects in a scene to their projection in the image. The second section describes how the optical image is converted into a pixelated digital image. The third section explains how this raw digital image is compressed into a more compact JPEG image.

Cameras

Several forensic techniques examine the consistency of the scene depicted in an image. To reason about a

three-dimensional scene from a two-dimensional image, we need a model of the camera's imaging process. A full description of a modern digital camera would require a separate book, but the original camera, the *camera obscura* (or pinhole camera), embodies the most important aspects of the imaging process, and it can be modeled with straightforward geometry and algebra. My description of the camera obscura will start with the simplified case of a two-dimensional scene and a one-dimensional image sensor.

1-D

A camera obscura is just a sealed box with a tiny pinhole in the front and light sensitive material on the interior back wall. Light emanating from a point in the scene (X, Z) enters the pinhole and strikes the sensor at location x (see figure 5.1 [a]).

You will notice in figure 5.1 (a) that the point in the scene is to the right of the camera's optical axis, yet its projection is to the left of this axis. This means that the image of the scene is inverted from left-to-right. Modern cameras flip the image back to its correct orientation, and we can easily incorporate this re-inversion by placing the pinhole behind the sensor (see figure 5.1 [b]). This relationship between the pinhole and sensor is not physically correct, but it simplifies the mathematical description of the image formation process.

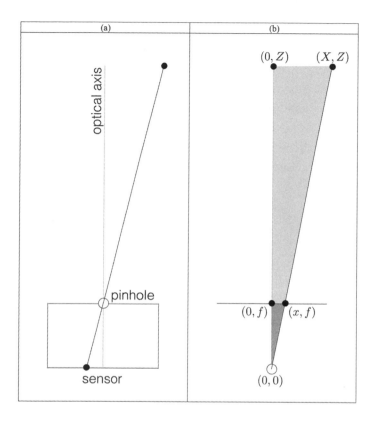

Figure 5.1 (a) A pinhole camera; (b) an inverted pinhole camera with the origin behind the sensor.

Now let's consider the pair of shaded triangles in figure 5.1 (b). The smaller triangle is defined by the points $(0, 0)$, $(0, f)$, and (x, f), where f is the camera's focal length, the distance from the pinhole to the sensor. The larger triangle is defined by the points $(0,0)$, $(0, Z)$, and (X, Z), where Z is the distance along the optical axis from the pinhole to the point in the scene. Because these are similar triangles, the ratio of the lengths of their sides is equal:

$$\frac{x}{f} = \frac{X}{Z}$$

Multiplying both sides of this equation by the focal length f yields the following *perspective projection* equation:

$$x = \frac{fX}{Z}$$

Let's explore some of the properties of the perspective projection equation using figure 5.2 (a). Consider the pair of far points at Z_1 (black) and the pair of nearby points at Z_2 (gray). In the scene, the distance between the points in each pair is the same, but, on the image sensor, the distance between the nearby points is larger than the distance between the far points. This makes sense intuitively because nearby objects appear larger than far objects. This

Figure 5.2 (a) Nearby objects Z_2 are imaged larger than distant objects Z_1; (b) objects are imaged larger with a larger focal length f_1 as compared to f_2.

also makes sense algebraically because in the perspective projection equation, the image coordinate x is inversely proportional to the distance Z.

Now consider the impact of changing the focal length f. Reducing the focal length from f_1 to f_2 in figure 5.2 (b) reduces the distance between points in the image. As the dashed lines indicate, this shorter focal length increases the field of view while decreasing the size of objects in that view. Algebraically this makes sense because in the perspective projection equation, the image coordinate x is proportional to the focal length f.

Last, let's examine a fundamental ambiguity in the image formed by a camera with a given focal length, f. If we start with a point in the scene (X, Z), we can determine its projected location in the image, x. But if we start with a location in the image, x, we cannot uniquely determine its location in the scene. This ambiguity is inherent in the geometry shown in figure 5.2 (b): all points along the line connecting the camera center $(0, 0)$ and the point (X, Z) project to the same location x. This ambiguity is also inherent in the algebra of the perspective projection equation: any pair of scene coordinates X and Z with the same ratio yields the same image coordinate x. This observation reveals why, without more information, it is impossible to uniquely reconstruct a three-dimensional scene from a single two-dimensional image.

2-D

The extension from a one-dimensional sensor to a two-dimensional sensor is straightforward. Light emanating from a three-dimensional point in the scene (X, Y, Z) enters the camera pinhole and strikes the sensor at some two-dimensional location (x, y). The perspective projection now takes the form:

$$x = \frac{fX}{Z} \text{ and } y = \frac{fY}{Z}$$

The perspective projection transforms a point in the scene's coordinate system to a camera coordinate system. Although this basic imaging model omits some aspects of the image formation process, it provides the necessary framework for reasoning about a three-dimensional scene from one or more two-dimensional images.

Pixels

We have described how light moves from the physical scene through a camera and strikes a sensor. At the sensor, light is converted into an electronic signal, which is recorded as a number. Sensors are designed to record what would be seen by the human eye. For this reason, many properties of sensors are related to those of the eye.

The eye has a light-sensitive lining, the retina, which consists of a single layer of photorecepotors. One type of photoreceptor, the rods, is specialized for vision under low light levels. The other type of photoreceptor, the cones, functions under bright illumination and encodes detailed information about the location and wavelength of light.

The information about wavelength encoded by the cones gives rise to our perception of color. Remarkably, we are able to distinguish some 10 million colors from just three wavelength measurements, each made by a different type of cone. The three cone types, L-cones (long), M-cones (medium), and S-cones (short), are named for the wavelength of light[1] to which they are most sensitive.

Analogous to the eye's three cone types, digital cameras have three channels with different peak sensitivities: R (red), G (green), and B (blue). This means that each pixel in a digital image is represented as three values: R, G, and B. A typical 24-bit digital image allocates 8 bits ($2^8 = 256$ distinct values) to each of three color channels. This gives rise to $2^{24} = 16,777,216$ distinct possible colors, on par with the human eye.

Similar to the eye, the typical digital camera sensor does not record all three colors at each location. Instead it only records a single color (red, green, or blue) and then fills in the missing color values through a series of post-processing steps (see Color Filter Array for more details).

The final digital image consists of an array of numeric values, three values at each element in the array. Each element is referred to as a *pixel* (picture element). A perfectly red pixel, for example, is given by the RGB triple [255,0,0], a green pixel by [0,255,0], blue by [0,0,255], yellow by [255,255,0], a dark red by [128,0,0], black by [0,0,0], and white by [255,255,255].

Camera resolution is specified in terms of the number of pixels in the final digital image. An image with 1,000 rows and 1,000 columns, for example, contains 1,000,000 pixels (one megapixel). Although the number of pixels is a good measure of image quality, there are a number of factors that dictate quality including, the quality of the lens, the light sensitivity of the sensor, and, as we'll describe next, the amount by which an image is compressed.

JPEG Compression

Although the underlying digital image is recorded as an array of pixel values, most digital cameras store a digital image using the JPEG (Joint Photographic Experts Group) compression format. Because several forensic techniques exploit certain properties of this format, it is worth providing a brief discussion of how it works.

The JPEG image format has emerged as the standard for devices that capture digital images. This image format

uses a *lossy* compression scheme that allows the user to trade-off memory size for visual quality. A highly compressed image requires relatively little memory for storage, but it may have noticeable distortion. A less compressed image will have greater fidelity to the original uncompressed image, but it requires more memory.

JPEG compression was designed to take advantage of our differential sensitivity to various forms of visual information. This compression scheme attempts to preserve the image information to which we are most sensitive while discarding information that we are unlikely to notice. For example, we are more sensitive to luminance contrast (a change from light to dark) than to color contrast (say, a change from red to green). Consequently, JPEG compression preserves more information about luminance than about color. JPEG compression also treats spatial frequencies differently. Spatial frequency is analogous to sound frequency, or pitch, which is measured in hertz (Hz). A high frequency sound (a squeak) has many rapid changes in air pressure per second, while a low frequency sound (a rumble) has fewer, slower changes in air pressure per second. Similarly, a high frequency visual pattern has many abrupt changes in luminance across space (the text on this page) while a low frequency visual pattern has only gradual changes in luminance across space (fog). In the range that is relevant for compression, humans

are more sensitive to low spatial frequencies than to high spatial frequencies, and, accordingly, JPEG compression preserves more information about low spatial frequencies than about high spatial frequencies.

I often receive emails from people asking me to analyze a photo that they are convinced is fake. As evidence of this fakery, they describe artifacts that appear to have been left behind from photo tampering. More often than not their analysis is, somewhat understandably, flawed. One of the most common mistakes made is that of confusing JPEG compression artifacts with the remnants of photo tampering. To avoid this confusion, it is important to understand how JPEG compression works in a bit more detail.

JPEG encoding

Given a three-channel color image, JPEG encoding consists of four basic steps:

1. The image is first transformed from a three-channel color image (RGB) to a three-channel luminance/ chrominance image (YCbCr). The luminance channel carries information about the brightness of each pixel, and the two chrominance channels carry information about color. The two chrominance channels (Cb and Cr) are optionally reduced in resolution horizontally

and/or vertically by a factor of two or more relative to the luminance channel (Y). The reduced resolution of the chrominance channels increases the amount of compression.

2. The image is then converted into a spatial frequency representation. First, each channel is converted from unsigned to signed integers (e.g., for an 8-bit image, from [0,255] to [-128,127]). Then the image is partitioned into non-overlapping 8 × 8 pixel blocks. Each block is converted to spatial frequency space using a discrete cosine transform (DCT).

3. Compression is performed on the spatial frequency representation of the image. The DCT values in each 8 × 8 block are quantized by an amount that depends on the frequency and channel they represent. To quantize a value c by an amount q, we divide c by q and round down to the nearest integer.[2] This quantization step is the primary source of compression and of visual distortion. To minimize visual distortion, the low frequencies are quantized less than the high frequencies and the luminance channel is quantized less than the chrominance channels. For low compression rates, the quantization values tend toward the minimum value of 1; for high compression rates, these values may exceed 20. This quantization has two benefits. First, non-integer DCT values are converted into integer values, which

require fewer bits to encode. And second, DCT values that are small and so largely imperceptible are mapped to 0. The benefit of many 0 values is realized next when the image is re-encoded in a more compact form.

4. In the final step of JPEG compression, the DCT coefficients are subjected to entropy encoding (typically Huffman coding). Huffman coding is a variable-length encoding scheme that represents frequently occurring values with shorter codes and infrequently occurring values with longer codes. This lossless compression can exploit the large number of 0 DCT values by efficiently encoding them with relatively few bits

JPEG decoding

The decoding of a JPEG image follows the same steps but in reverse order: the Huffman encoding is decoded, the DCT values are rescaled by multiplying by the corresponding quantization value,[3] an inverse DCT is applied to each 8×8 block, the pixel values are converted from signed integers to unsigned integers, the chrominance channels are returned to their full resolution (if necessary), and the luminance/chrominance (YCbCr) channels are converted to color channels (RGB).

This compression introduces a number of different artifacts into an image:

1. The partitioning of an image into 8×8 blocks followed by the quantization in step 5 introduces a grid like pattern along the block boundaries;

2. the quantization in step 5 blurs details in the image;

3. color artifacts are introduced owing to the reduction in resolution of the chrominance channels in step 2 followed by the quantization in step 5;

4. and, object boundaries can appear jagged.

Figure 5.3 [plate 21] is a magnified portion of an image with and without compression that highlights these four artifacts. When viewed at normal magnification, these artifacts may not be visible. When magnified, however, the compression artifacts become pronounced and look suspicious. While it can certainly be useful to magnify an image, it is imperative not to confuse these JPEG compression artifacts with traces of tampering.

Figure 5.3 [plate 21] An uncompressed (bottom) and JPEG compressed (top) image highlighting four common compression artifacts.

GLOSSARY

Aperture
the opening in a camera that admits light; the size of the aperture controls the amount of light that enters

CFA (Color Filter Array)
an array of color filters aligned with the light-sensitive elements of the camera sensor; each filter passes light in the red, green, or blue range of the spectrum

DCT (Discrete Cosine Transform)
generates a frequency representation of an image; a key step in JPEG compression

Depth of field
the distance between the nearest and farthest objects that appear focused in an image; also referred to as the range of focus

EXIF (Exchangeable Image File Format)
a format for image metadata

Field of view
the angular extent of the scene captured by a camera

Focal length
the distance between the camera lens and the camera sensor

Foreshortening
a perceived distortion in the shape of an object owing to perspective projection; the telescoping of distances along the line of sight

GPS (Global Positioning System)
some cameras contain a GPS that tags the geographic location where an image was captured

RGB (Red, Green, Blue)
the three channels of a color image

Homography
a linear transformation of points from one plane to another plane

Huffman coding
a method for compressing a signal without any loss of information; uses shorter codes for the more common elements in the signal

ISO (International Standards Organization)
the sensitivity of the camera sensor; the higher the ISO, the more sensitive the sensor is to light; determines the amount of light required for a properly exposed image

JPEG (Joint Photographic Experts Group)
a common method for compressing an image so that it requires less memory for storage; discards information that is not perceptually salient; the lower the JPEG quality, the more information discarded, the less memory required

Lens distortion
geometric image distortion resulting from lens imperfections in which straight lines appear curved

Pixel
"picture element"; the smallest unit of information that makes up a digital image

PRNU (Photo Response Non-Uniformity)
slight variations in the sensitivity of a camera's sensor elements; creates a subtle pattern that can sometimes be used to link an image to a particular device

Optical axis
a line centered in the middle of the camera sensor and perpendicular to the camera sensor

Principal point
the intersection of the camera's optical axis and sensor

Sampling lattice
a regular repeated 2-D arrangement of elements

Sensor
a camera sensor records an image by converting light into an electronic signal

NOTES

Chapter 1

1. EXIF: Exchangeable Image File Format; XMP: Extensible Metadata Platform; IPTC-IIM: International Press Telecommunications Council—Information Interchange Model.

2. The image thumbnail is a small version of the full resolution that is used to provide a quick preview of an image.

3. Consider the world points (Δ, Z) and $(X+\Delta, Z)$. These world points project to $f\Delta/Z$ and $f(X+\Delta)/Z$. The length of the segment between these points is: $f(X+\Delta)/Z—f\Delta/Z = (fX/Z + f\Delta/Z)—f\Delta/Z = fX/Z$, which is independent of the horizontal displacement Δ.

4. Be careful to distinguish between the focal length and the 35 mm equivalent focal length, both of which may be reported in the image metadata. The 35 mm equivalent focal length corresponds to the focal length assuming a 35 mm sensor size. This allows for a consistent comparison of focal lengths across cameras of different sensor sizes, but it should not be used in the calculation of distance. Some digital cameras provide both an optical and digital zoom capability. Digital zoom will not be reflected in the focal length but will affect length measurements made in the image. The image-based measurements should therefore be divided by the amount of digital zoom. Like the focal length, the digital zoom will (should?) be recorded in the image metadata.

Chapter 2

1. There are three basic variants of the JPEG file format: (1) the JPEG Interchange Format (JIF); (2) the JPEG File Interchange Format (JFIF); and (3) the JPEG/EXIF format. The JIF format is the full-featured version, which is rarely used because of the difficulty associated with building a fully compliant encoder and decoder. The more common JFIF and JPEG/EXIF are simpler subsets of the JIF format.

2. Ignoring overlapping regions and the edges of the image, there are 1,000,000 choose 2, equal to (1,000,000 x 999,998)/2 = 500,000,000,000 possible pairings of pixels, each of which may be the center of a pair of cloned regions.

3. The Warren Commission report states that at the time of his arrest, Oswald gave his weight as 63.5 kg (140 lbs) but on other occasions he gave weights

of both 63.5 kg and 68 kg (150 lbs). The New Orleans police records of his arrest show a weight of 61.7 kg (136 lbs), and the autopsy report indicates an estimated weight of 68 kg. Given the conflicting weights, I'll assume a weight of 64.4 kg (142 lbs), the average of the various reported weights.

Chapter 3

1. The round down (or *floor*) of a number c is the largest integer less than or equal to c. For example floor(2.1) = 2, floor(2.5) = 2, and floor(2.9) = 2.

2. Spatial frequency is analogous to sound frequency. A high frequency sound has many rapid changes in air pressure per second, while a low frequency sound has fewer. Similarly, a high frequency visual pattern has many abrupt changes in luminance across space while a low frequency visual pattern has fewer.

3. Long wavelength light appears red and orange, medium wavelength light appears yellow and green, and short wavelength light appears blue and violet.

4. The ISO governs the sensitivity of the sensor (see Exposure). In low light conditions, a high ISO is used to make the sensor more sensitive to small amounts of light.

5. Hao-Yu Wu, Michael Rubinstein, Eugene Shih, John Guttag, Frédo Durand, and William Freeman, "Eulerian video magnification for revealing subtle changes in the world," *ACM Transactions on Graphics* 31, no. 4 (July 1, 2012): 1–8.

Chapter 5

1. Long wavelength light appears red and orange, medium wavelength light appears yellow and green, and short wavelength light appears blue and violet.

2. By way of example, quantizing 12.5 by 3 yields 4; quantizing 8.9 by 5 yields 1; and quantizing 3.2 by 7 yields 0.

3. Although we can return the DCT value to its original scale by multiplying by the quantization value, there is no way of recovering the original non-integer value, which is lost after conversion to an integer. This is why JPEG compression is "lossy."

The MIT Press Essential Knowledge Series

HANY FARID is Professor, School of Information and School of Computer Science and Electrical Engineering, University of California, Berkeley.